India
Remembered

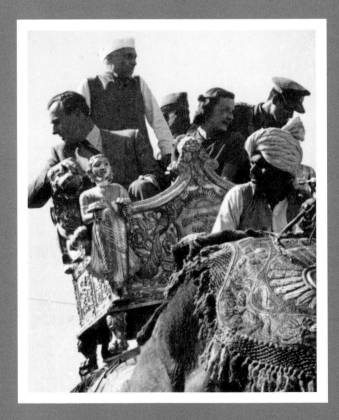

My parents with Nehru on an elephant proceeding to the Mela.

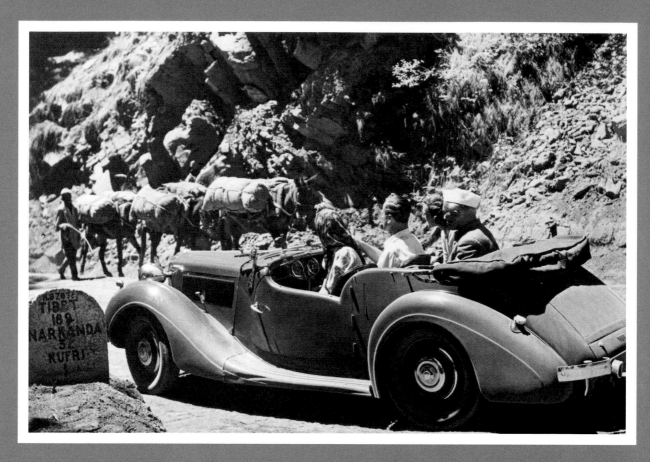

*17th May 1948: My father driving my mother, myself and Nehru
on the Tibet Road from Mashobra.*

India
Remembered

Pamela Mountbatten

Foreword by India Hicks

PAVILION

First published in the United Kingdom in 2007 by
Pavilion Books
151 Freston Road
London W10 6TH

An imprint of Anova Books Company Ltd

Publisher: Kate Oldfield
Editor: Kate Burkhalter
Designer: Lotte Oldfield
Indexer: Derek Copson
Maps: William Smuts

ISBN 9781862057593

A CIP catalogue record for this book is available from the British Library.

2 4 6 8 10 9 7 5 3 1

Reproduction by Mission Productions Ltd, Hong Kong
Printed and bound by SNP Leefung Printers Ltd, China
www.anovabooks.com

Contents

The Concise Mountbatten Family Tree

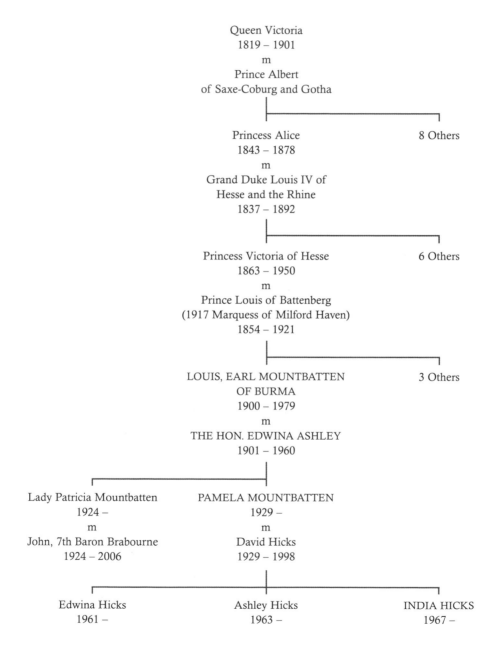

Queen Victoria
1819 – 1901
m
Prince Albert
of Saxe-Coburg and Gotha

Princess Alice 8 Others
1843 – 1878
m
Grand Duke Louis IV of
Hesse and the Rhine
1837 – 1892

Princess Victoria of Hesse 6 Others
1863 – 1950
m
Prince Louis of Battenberg
(1917 Marquess of Milford Haven)
1854 – 1921

LOUIS, EARL MOUNTBATTEN 3 Others
OF BURMA
1900 – 1979
m
THE HON. EDWINA ASHLEY
1901 – 1960

Lady Patricia Mountbatten PAMELA MOUNTBATTEN
1924 – 1929 –
m m
John, 7th Baron Brabourne David Hicks
1924 – 2006 1929 – 1998

Edwina Hicks Ashley Hicks INDIA HICKS
1961 – 1963 – 1967 –

Foreword

by India Hicks

I have led by all accounts an unusual life, coming from an unusual family, carrying with me an unusual name. But my unusual life pales in comparison to that of my mother's. I implored her to tell this extraordinary tale, exactly sixty years later.

I never knew my grandmother, but I clearly remember being told that once after a dinner party in India many years after Independence she was asked who she had sat next to. She replied that he had been a most amusing dinner guest, and when asked if he had been black or white, she simply could not remember.

I knew my grandfather; he was the backbone to our lives. I remember small 'tasks' he would set me, standing tiptoed on a chair pushing his shoulders back hard against a stone wall 'harder child, harder' he would yell; or tickling a blade of grass across his upper lip as he snoozed in the afternoon, 'softer child, softer'. He was the indominatable yet gentle giant, until one sunny August day in Ireland the clouds descended on that childhood forever.

It is hard for me to imagine my grandfather, only a few years older than I am now, being asked to dismantle an empire. Unimaginable the responsibility of stemming the tide of violence and controlling cities that were committing suicide. It is not hard, however, to imagine that from the moment my

grandparents arrived, they rejected all the Raj stereotypes and looked towards the job with open minds. It is also understandable that, despite his royal ties, my grandfather was a tough-minded realist, committed to those liberal principles which made him acceptable to Atlee's Labour party. Gandhi, the soft-voiced archangel of India's independence, sensed my grandfather's warmth and responded to it, as he had been unable to do with any previous Viceroy.

Criticism over the damnable haste in bringing British rule to an end has never softened. The blunt fact is that no one foresaw the magnitude of the horrors that lay in wait, and their failure to do so would baffle historians in later years. Nehru and Jinnah each made the grave error of underestimating the communal passions which would inflame the masses of their subcontinent, but it was the relative newcomer in their midst, the Viceroy, who took the blame from the rest of the world.

I have travelled my way around this great country, whose name I so proudly carry, staying in youth hostels, occasionally sickened by the unexpected glimpse of India's timeless miseries or staying in Government houses of considerable magnitude, lavished upon by luxury. Never once during my numerous visits have I ever encountered an Indian within India who, on discovering who my grandparents were, had any other reaction than to smile from ear to ear and beam in fond remembrance as at an old friend, which is how a generation seems to have regarded them.

The role of last Viceroy of India was a poisoned chalice from which my grandfather had been asked to drink. Despite this, my grandparents were successful in moving a country in flames forward, and it was an immense personal tribute to my grandfather to accept Congress's invitation to become the first Governor-General of the Dominion.

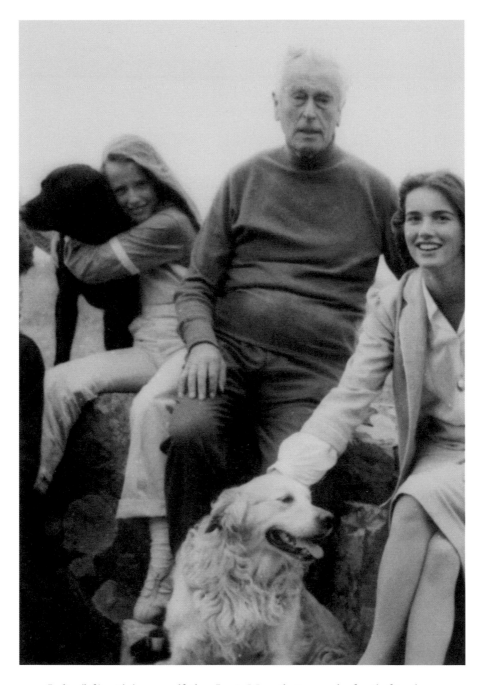

India (left) with her grandfather, Louis Mountbatten, and a family friend.

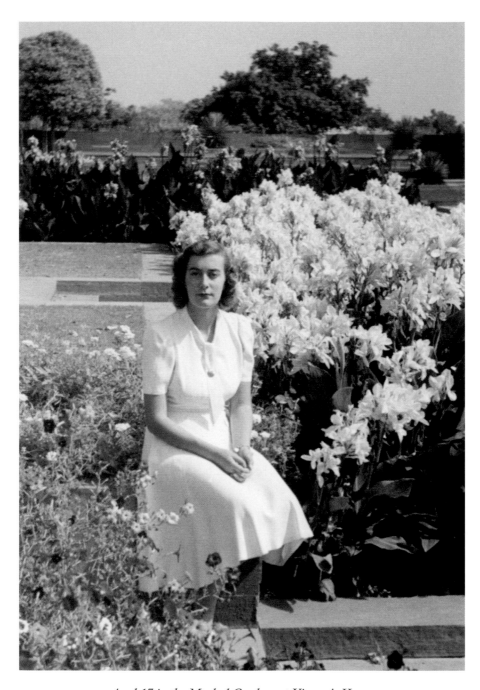

Aged 17 in the Moghul Gardens at Viceroy's House.

Introduction

by Pamela Mountbatten

I certainly never planned to write about the time I spent in India with my parents when my father was Viceroy, but I was finally persuaded by my younger daughter – anything for a quiet life. But then again, I find myself pushed into doing all sorts of things I never intended. My daughter India is very, very determined, encouraging me to go riding in Patagonia, undertake safaris and exotic travel, which I had never thought to go on, but which proved unforgettable in her company. On one occasion, however, she did become over-enthusiastic. She telephoned me from New Zealand to say that she had just booked my seventieth birthday present. I was to go hang gliding: 'You'll love it, Mum. It's thrilling and you'll only have to run five paces to take off.' I panicked and flatly refused to go. She took me swimming with dolphins instead.

This project is the result of another of her persuasive assaults. At first I simply handed over the diary I began as a seventeen-year-old. Then we went to look in the Broadlands' Archives at my father's photograph albums which he had kept meticulously during his time in India. The pages of his most important album are organised by date and event and carefully captioned in his neat handwriting. As we turned the pages together I found myself remembering those extraordinary months with a vividness

reawakened after sixty years. India had many questions and was also overawed by what she saw – an eyewitness account of one of the most momentous events in modern history. When I saw her reaction, I realised that she was right: I should publish my memories of this period. Since that day we have spent many hours together surrounded by letters, typescripts and images, trying to piece together that time again in a book that might be intensely personal but also accessible to a new generation of readers.

The book we have put together combines the photographs my father assembled with my diaries from that period. It brings it alive to read my seventeen-year-old self, so young in many respects and yet mature enough to understand the importance of the events that erupted around us. I have left many of the passages in that girl's voice, even though time and experience have since afforded me the gift of greater objectivity.

The time-frame of our stay was March 1947 to June 1948. The Indian sub-continent was divided into two independent Dominions, India and Pakistan, in August 1947 and my father was asked to stay on by Nehru for another ten months as Governor-General of India, a great honour. My father always recognised the importance of records and he encouraged me to keep a diary. Of course when things get interesting, one's diary entries tend to become shorter or dry up all together because life becomes so hectic, but I am grateful for my father's persuasion now. I wrote in it regularly in the days leading up to partition but then in September and October, when I was working hard as General Rees's assistant, there was obviously less time to write and the entries are fewer and further between. By the time my sister and her husband had flown out to join us in December and we began to travel (attempting to visit every state and province in the few months before our departure), the diary was often neglected.

The build up to our departure had its equal share of wracked nerves and excitement, as I record on the pages between New

Year's Day and our departure from RAF Northolt on 20th March. My first entry for 1947 sets the tone for the year and a half to come. We were on a family holiday in Switzerland. My parents had been over-working as usual and were just beginning to relax and my newly married sister, Patricia, and her husband John Brabourne were with us. But my father was summoned to a meeting by the Prime Minister, Clement Attlee.

I write in my diary:

Wednesday 1st January
Daddy was suddenly recalled yesterday by the PM to London and consequently our New Year's party was slightly gloomy and harassed, particularly as everything now is so uncertain. He and Mummy left this morning which really is very sad as at last we were all together.

The 'together' here emphasises how special it was to be together as a family. Obviously my parent's work had meant that we saw very little of them during the war. For children with fathers fighting in the Far East those last three months were very hard. We were surrounded by the euphoria of everyone celebrating peace in Europe and forgetting the intense fighting against the Japanese. My father took the surrender of the Japanese in Singapore on 12th September. But he had to remain to hand over power to the newly independent governments of Burma, Malaya and Indochina, which became Indonesia, and the Dutch East Indies, and to install the nineteen-year-old Ananda as King of Siam. He only returned to London on 30th May 1946, but my parents immediately left on an official visit to Australia.

During the war, when not at boarding school, I lived with my paternal grandmother, who, as a granddaughter of Queen Victoria, was Princess Victoria of Hesse. She married my grandfather Prince Louis of Battenberg. During the Blitz on London, my father persuaded my grandmother to leave Kensington Palace and come to live at Broadlands, our home

in Hampshire. She was a royal princess so I had been brought
up to curtsey to her and kiss her hand. This was alarming to my
school friends who came to stay but she was a fascinating old
lady and they were enthralled by her. Life at boarding school
during the war was run on simple lines, as were most people's
lives during those austere years. Therefore the New Year
holiday of 1946/47 had been anticipated with great excitement.

The diary entry also hints at the other spoke in the works at
this time – the fact that everything about my father's potential
new job was so 'uncertain'. As has been recorded frequently,
it is no secret that my father did not want the job of Viceroy.
The command to divest England of the last jewel in the Empire,
garnered under his great grandmother, was not an easy one to
accept. He also knew that it could mean the ruin of what had
so far been a glorious career, for India was wracked with political
troubles and many before him had failed to forge a straight path
towards independence.

The deadline of June 1948 had been set but there was no clear
idea as to how to meet that date successfully. My father therefore
made his feelings of reluctance known and also threw in some
strong provisos, including the use of his old aircraft, a York,
which he had used in South East Asia. He also requested a
commitment from the board of Admiralty that he might return
to the navy when the job was over and, most important of all,
what were virtually plenipotentiary powers. He felt that he had
to be allowed to act on his own initative
without having to refer everything back to Whitehall. And finally,
when it looked as though the Prime Minister and the Cabinet
might accept all these demands, he went to the King. 'Bertie,'
he said, 'they will be sending me out to do an almost impossible
job. Think how badly it will reflect on the family if I fail.'
But the King replied, 'Think how well it will reflect on the family

Right: My father's letter to the Prime Minister, Clement Attlee.

20th December, 1946.

My dear Prime Minister,

I am deeply honoured by the offer you have
made me, to succeed Wavell. I understand you
to say that you wished me to try and end the
present deadlock and enable the Indian parties to
agree on their future constitution.

I know you would not wish me to accept your
offer unless I felt I had a reasonable chance of
succeeding in these tasks. And I do not feel I
could tackle this job with confidence if the
matter of my appointment suggested to the Indians
that we wished to perpetuate the Viceregal system,
or intended to exercise the right to impose our
nominees to arbitrate in their affairs.

I feel, at this late stage, such an
impression would constitute a disadvantage which
neither Wavell nor the Cabinet Mission had to face.

In the circumstances, I feel I could only be
of use to you if I were to go out at the open
invitation of the Indian parties, in a capacity
which they would themselves define.

Yours very sincerely,

(signed) MOUNTBATTEN

if you succeed,' and told him he must go. In fact, unknown to us at the time, Nehru himself had put my father's name forward as a potential candidate in his meetings with Sir Stafford Cripps during the Cripps mission of 1946 when the British Government had become committed to a policy of complete independence for India. My mother recorded in her diary of 17th February, 'At home all day but constant conferences and long distance calls!'

Finally all was agreed:

Thursday 20th February
I went with John and Patricia to the House to hear the statement that Daddy was to become Viceroy read by the PM. It was very crowded and before everyone had become very uproarious during Question Time so that it dissolved into complete chaos, Winston demanding why Wavell was to be recalled and Attlee refusing to give further explanations.

Preparation

The following day my mother and I went shopping with her French dressmaker to try to find materials to make up into suitable dresses. We only had four weeks before we were to fly out. There were some beautiful materials, far better than we had been used to during the war. But we did not have enough clothing coupons, even with the small extra allocation that we were allowed, so we had to be very modest in what we bought. It was exciting for me to have anything new. My mother ordered some dresses from Molyneux, including a beautiful embroidered satin evening dress.

My father introduced me to what was to become my new life by teaching me elementary Urdu out of a handbook for Army cadets. My mother arranged for Miss Lankester, who had worked for the All India Women's Conference, to come and talk to me about the students in India and the various contacts that

I might be able to make. Coming from an English boarding school I was woefully ignorant of politics and international affairs. I felt entirely unprepared to go to another country with so many diverse political parties and such profound problems.

My parents had become engaged to be married in India in 1921. My father was an ADC to the Prince of Wales on his tour of the Far East. My mother and father had fallen in love before he left and he persuaded her to visit India, which she longed to see, while he was there with the Prince. She was barely twenty and had no money of her own, so she borrowed enough for the fare and found herself a chaperone from the list of passengers. The Vicereine, Lady Reading, was an old friend of her beloved great aunt and invited her to stay. One evening my father asked the Prince to lend him his private sitting-room in the Viceregal Lodge (now part of the University in old Delhi) and there he asked her to marry him. When she heard they were engaged, the Vicereine was horrified. She had hoped Edwina would have chosen someone older, 'with more of a career before him.'

Family Ties

My father's mother was Princess Victoria of Hesse, who was a granddaughter of Queen Victoria. He was born at Frogmore House, in the Home Park of Windsor Castle, in 1900. He was christened Louis Francis Albert Victor Nicholas, but very soon became known as Dickie. His elder sister, Princess Alice, married Prince Andrew of Greece and their youngest child, Philip, became the present Duke of Edinburgh.

My paternal grandfather was Prince Louis of Battenberg, who in 1917 became Marquess of Milford Haven when King George V anglicised the royal family names, and our family name was translated into Mountbatten. My grandfather had been forced to resign from his post as First Sea Lord in October

1914, following a hysterical wave of anti-German feeling – he was a German by birth – a humiliation which my father felt had been expunged when he himself became the First Sea Lord in June 1950.

My mother, Edwina, was the daughter of Lord Mount Temple. She and my father were married in 1922. By the time they arrived in India in 1947 as Viceroy and Vicereine my father was forty-six and my mother forty-four. He was enthusiastic, pragmatic, extrovert, a raconteur and fascinated by his family connections, but above all extremely hard-working. She was an introvert, but fearless and excited by action, and bored by protocol and old-fashioned apathetic comfortable society. They worked well as a team; my father had appointed her towards the end of the war to fly into the prisoner of war camps, and report back to him on the conditions. He had a very high opinion of her abilities.

My father trusted her decisions implicitly. For instance, when we met as a family for breakfast, he would simply ask her, 'What decisions did you make?' 'Who did you see?' And of course, her special relationship with Pandit Nehru was very useful for him – ever the pragmatist – because there were moments towards the end of our time in India when the Kashmir problem was extremely difficult. Pandit Nehru was a Kashmiri himself, so he was emotional about the problem. If things were particularly tricky my father would say to my mother, 'Do try to get Jawaharlal to see that this is terribly important...'

The England We Left Behind

January 1947 in England brought eight weeks of snow and the coldest night ever recorded. There were eighteen-foot drifts in the north with cut-off villages having food supplies dropped in by parachute. There was a coal crisis and interminable power cuts throughout the country. It was terribly cold and dark everywhere.

When the light was on it was so dim one could scarcely read. Going into large stores we found them to be in almost complete darkness except for a couple of candles. Enormous numbers of people were unemployed as industries closed down.

We were still in the grip of austerity. Food was rationed and our meagre sweet ration was eaten in a flash. Kind-hearted American friends still sent food parcels containing delicious dried fruit and soup but no cooking fat or sugar, which was what we lacked most of all. India and Viceroy's House were going to be very different from England. When we left for India my mother took her old Sealyham terrier, Mizzen, as she could not bear to leave him in case he died before our return. When we arrived at Viceroy's House she asked if she could have some food for him. Breast of chicken arrived on a silver salver. My mother locked herself in the bathroom and ate it.

Soon after it was announced that my father was to become Viceroy, we drove up to London in an Admiralty car. The roads were still terribly icy and when the driver braked in traffic we skidded sideways into an army trailer and rebounding, crashed into another. The car was too smashed to continue but luckily a London-bound bus pulled up behind us. We climbed aboard with my father muttering that he would be late for the PM at Downing Street, which I remember thrilled and delighted the curious passengers around us. I went with my parents to have tea with Queen Mary and the Duke of Gloucester at Marlborough House. She was always awe-inspiring but on this occasion she was amused to hear how indignant my grandmother was about my father taking on 'the politicians' dirty work'.

My mother's diary entry for 14th March records that they had 'gala photos taken' in which you can clearly see her orders and decorations: The Crown of India, Grand Cross of the Order of St. John, Grand Cross of the British Empire, Dame Commander of the Victorian Order and Honorary Doctor of Law.

We gave a farewell cocktail party for seven hundred at the RAC, of which my father was President. It was a great success and justified my parents having rejected the Dorchester's much reduced but still alarming quote of twenty-five shillings a head. My father's Press Attaché, Alan Campbell-Johnson, records that 'every celebrity in London was there.' My mother, with characteristic delight at her 'inclusive' attitude to society, took pleasure in the fact that among the celebrities were ordinary people from their lives 'including the caretakers at my office.'

Thursday 20th March
We drove down to Northolt, the Royal car bulging with bodies, dogs and packages and the whole fleet of cars preceded into the airport by a very dusty baby Austin! Daddy has got his famous York back which he toured all af SEAC in. Everyone came to see us off, an action which ought to be stopped by law.

A Special Relationship

India remained a magical place for both my parents. My father set up his South East Asia Headquarters in Faridkot House in New Delhi during the Second World War when he first took up his job as Supreme Allied Commander, so I had heard many family stories. But my main source of knowledge about India was provided by Rudyard Kipling and the photograph of Mahatma Gandhi wearing his *dhoti* and shawl, surrounded by cheering mill workers in Lancashire.

My parents had met Pandit Nehru in 1946 when he had travelled to Malaya to meet the Indians living there. My father was Supreme Allied Commander and some of his staff warned him that there might be trouble and were against his meeting Nehru. One of his staff had already refused to provide transport for the visitor. When he heard this my father was furious.

He drove with Pandit Nehru in his official car to the YMCA in
Singapore, where the meeting was being held. My mother was
already there with a group of Indian welfare workers. As she
came forward to be introduced, a crowd of Panditji's admirers
swarmed in behind him and she was knocked off her feet.
She crawled under a table from where Panditji rescued her.

Towards the end of the fifteen months we spent in India
the immediate attraction between my mother and Panditji
blossomed into love. Nehru was a widower and his daughter,
Mrs Gandhi, was still married with a husband to look after,
and was not often around. He had sent his sister as ambassador
to Moscow, and then to New York, and he didn't see much of
his second sister, who was in Bombay. If you are at the pinnacle
of power you are alone; whatever you say to your colleagues is
likely to be immediately broadcast, so you can't talk to your
political collaborators at all and you are lonely. She became his
confidante. Nehru would never write to her until about two in
the morning, when he had finished his work, and his letters
were a fascinating diary of the creation of India. He would
start with a charming opening paragraph, very touching and
personal, and he would end affectionately. But the main part of
the letters were a diary of everything he had been doing and the
people he had seen, his hopes and fears, and, towards the end
of this twelve-year correspondence, his disappointments
and disillusion.

My mother had already had lovers. My father was inured to it.
It broke his heart the first time, but it was somehow different with
Nehru. He wrote to my sister in June 1948: 'She and Jawarhalal
[sic] are so sweet together, they really dote on each other in the
nicest way and Pammy and I are doing everything we can to be
tactful and help. Mummy has been incredibly sweet lately and
we've been such a happy family.'

So there existed a happy three-some based on firm under-
standing on all sides. This letter was written I suppose because

their relationship had deepened the month before, in May, when we had gone to the retreat at Mashobra and my parents, and indeed Panditji, found themselves able at last to relax a little for a few days. Everyone had been too busy to work on friendships until that point, but I think it was that trip that was really special for us all. Nehru referred to this in a letter to my mother written much later, in March 1957:

Suddenly I realised (and perhaps you did also) that there was a deeper attachment between us, that some uncontrollable force, of which I was dimly aware, drew us to one another, I was overwhelmed and at the same time exhilarated by this new discovery. We talked more intimately as if some veil had been removed and we could look into each other's eyes without fear or embarrassment.

The relationship remained platonic but it was a deep love. And although it was not physical, it was no less binding for that. It would last until death. They met about twice a year. She would include a visit to India in her overseas tours on behalf of the St. John Ambulance Brigade and the Save the Children Fund. From the beginning she would continue to oversee the work of rehabilitation and relief which she had set up for the refugees uprooted by Partition.

Panditji would come to London for the Commonwealth Prime Ministers' conferences. He would always come down to Broadlands, our house in Hampshire, for a weekend. We kept a little grey mare for him so that he could come out riding with us.

My mother was on an overseas tour in 1960 and had just left India, carrying out a heavy programme of inspections and engagements in Borneo, when her heart gave out and she died in her sleep aged fifty-eight. A packet of letters from Panditji was found by her bedside. In her will she left the whole collection of letters to my father. A suitcase was crammed full of them. My father was almost certain that there would be nothing in the

letters to wound him. However, a tiny doubt caused him to ask me to read the letters first. I was happy to be able to reassure him. They were remarkable letters but contained nothing to hurt him.

On my mother's death, the two Houses of the Indian Parliament stood in silence in her memory and a frigate from the Indian Navy attended her funeral at sea off Portsmouth. They cast a wreath of marigolds into the ocean on behalf of the Prime Minister, Nehru.

For me, Pandit Nehru was a very special person. I felt a tremendous warmth towards him from the first time I met him. The whole time we spent in India was no more than sixteen months: very short, but it seemed like a lifetime, and if you had asked me whom I loved most after my father and mother, or my sister, undoubtedly it was Panditji. I called him 'Mamu', which means 'Uncle'. I remember that Panditji frequently used the expression 'All manner of things' – he said it to such an extent that we used to tease him about it. My father also felt a real affection for him.

The Need for Speed

There has been criticism after the event about the speed of the transfer of power. To all the leaders struggling to solve the problems at the time, this speed was essential. My father became Viceroy on 23rd March 1947 with the date for the transfer given as June 1948. It seemed a very short time for so much to be resolved. In fact, it soon became clear that it must happen much sooner.

India had long wanted self-government. The First World War had weakened the power of the British in India, and Gandhi's arrival from South Africa and his subsequent and effective advocacy of non-violent civil disobedience greatly strengthened the (Hindu) Indian National Congress, founded in 1888, which

in 1929 declared itself for the complete independence of India. The Hindus, dominant in trade in the towns and cities, took better advantage of British rule than the oppressed Muslims, but Britain had not helped the situation, exploiting the divide between Hindus and Muslims by giving the Muslims their own electorates and encouraging their very different culture and history. The idea of a separate Muslim sovereign entity arose in 1933, complete with a proposed name, Pakistan, and was adopted by the Muslim League, founded in 1906. Differences and difficulties multiplied.

As the Second World War threatened to engulf India in 1942, Sir Stafford Cripps, Lord Privy Seal and Leader of the House of Commons, was sent out on a mission to offer Gandhi self-governing dominion status for India after the war, in return for support for the British war effort. He was turned down flat: Gandhi wanted independence now, or not at all, and the result was the Quit India movement.

Muslim frustration broke into violence on Direct Action Day, 16th August 1946, when after three days of dreadful slaughter 20,000 Muslims and Hindus lay dead in the streets of Calcutta. It was the signal to the Muslim leader Jinnah that India must be either divided, or destroyed, and the signal to Prime Minister Atlee in Britain that independence could no longer be postponed. He needed a new Viceroy to see it through.

Lord Wavell, the current Viceroy, was a good man and well respected, but he was not held in affection, nor in confidence. He was also hamstrung by the government in not being allowed to talk to Gandhi, around whom so much revolved. He had been unable to secure cooperation from the Muslim League and had no solution to the problem other than his 'Operation Madhouse', a phased and complete withdrawal of British civil and military personnel. Attlee realised that a new man, a different personality, was required – and that man should be my father. He had in fact been proposed previously, by Leo Amery in 1942, and in 1945

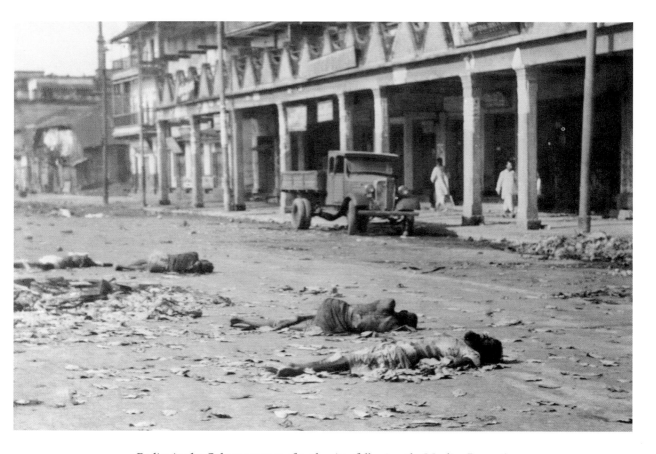

Bodies in the Calcutta streets after the riots following the Muslim League's Direct Action Day in August 1946.

he had written to my mother, from Karachi, to tell her, 'You would make the world's ideal Vicereine.' In 1946 Krishna Menon had put his name forward as a Viceroy acceptable to Congress and Atlee perceived him as 'an extremely lively, exciting personality.' He had 'an extraordinary faculty for getting on with all kinds of people,' and was also 'blessed with a very unusual wife.'

A popular hero, a liberal, and perhaps best of all, the King-Emperor's cousin, my father was dispatched to India to oversee the granting of independence no later than June 1948.

It was an urgent task. The conflagrations had spread to Bihar and East Bengal. Punjab was ready to ignite at any time. And of course, there was nothing to counteract this growing force: the Indian Civil Service had ceased recruiting since the beginning of the Second World War and the British troops were all going home. There was no way that an inflammable situation could be controlled. All the Indian political leaders told my father that the handover must take place as soon as possible and this was a view corroborated by the Governors at the Governors' Conference in Delhi in April and backed by Lord Ismay, my father's Chief-of-Staff. The state of uncertainty was unbearable and a terrific feeling of urgency prevailed. Dominion Status was proposed as a solution to give both countries support within the Commonwealth. At the start of June, after the announcement that the plan for Partition had been accepted, there was an enormous press conference and in answer to the all-important question, my father replied that the Transfer of Power would take place on the 15th August 1947. This would be ten months earlier than the original deadline but it was necessary if there was any hope of avoiding civil war.

My India

My crucial late teenage years were spent in India, so the times when I sat with my peers in earnest discussion about important things in our lives and generally gossiped, chatted and giggled, was with a group of Indian girlfriends which included Muslims, Hindus, Sikhs, Christians and Buddhists. There seemed to be no divisions. We were just young girls enjoying life and each other's company.

Many of my friends were students at the Lady Irwin College, an all-female establishment which later became part of the

Right: With Panditji at Palam airport.

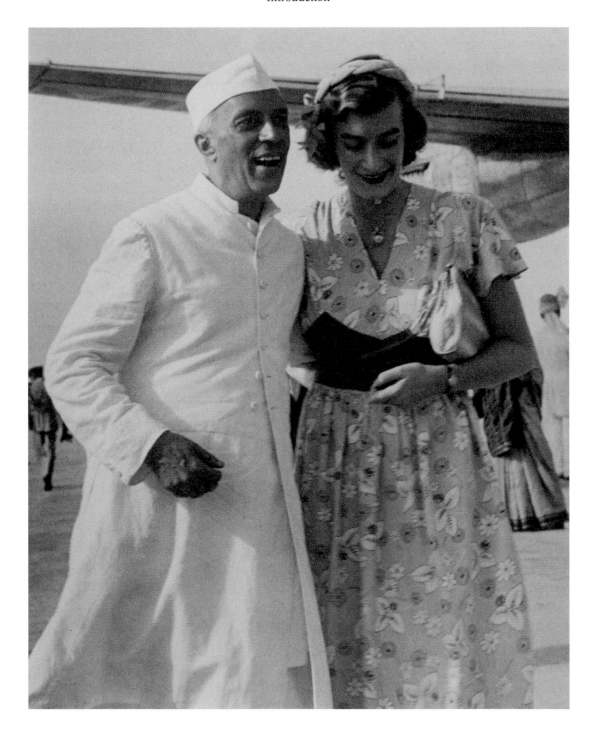

University. Only occasionally was I brought up short by the unexpected. Once we were discussing what we would do when we were twenty-one and one girl said 'Oh, but I will be dead.' So we said, 'What do you mean?' – we were all eighteen or nineteen at the time – and she said, 'Well, they cast my horoscope when I was born, and then they would never let me see it, never. The one thing I wanted to see was my horoscope, and it was put away in my father's study. One day I found it when they were all out, and I read that I will die when I am twenty-one.'

Throughout the politically heavy days there were plenty of welcome distractions in the form of animals which had always played a great part in our lives.

As I described in a rare letter home to my friend Mary:

It really is such fun out here seeing all the birds and animals, the little green parrots and the ridiculous little crested hoopoes, and the bullocks and jackals and camels. We have a baby mongoose as a pet. He is very sweet and tame and they make extremely good pets as they love company and although timid are hopelessly inquisitive so that they are great fun.

There were always lots of monkeys up at Viceregal Lodge in Simla. They looked very sweet with their little black faces and when it was the season for every female to have a baby with her they looked perfectly charming. Of course they were as naughty as any monkey and they stole everything.

We'd been given a baby mongoose which we called Neola, rather unimaginatively I'm afraid, as it merely means 'mongoose'. Neola grew fast but as he'd been removed from his mother, my father thought it necessary that we fill her place and he was very distressed to find that Neola did not know how to crack his own

*Right: In the garden at Broadlands with my parents
and our mongoose, Neola.*

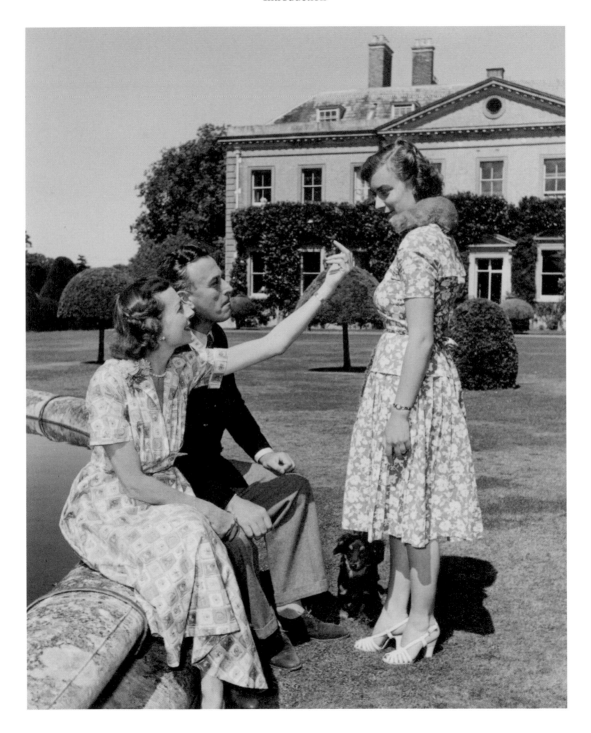

egg. He loved eating eggs but whenever he tried to bite the shell of the egg of course it snapped out of his jaws and he was very frustrated. My father remembered from Rudyard Kipling's *Riki Tikki Tavi*, what a mongoose is supposed to do. On the floor, you take the egg in your front paws and, with your back legs apart, take it near a rock or a door or wall and throw the egg against this hard thing, whereby it shatters and you can then eat your egg. We didn't quite know how to get this through to Neola. My father said, 'well it's perfectly easy.' He got down on the floor and he demonstrated. He'd got his legs apart and had thrown the egg against the wall when a Chaprassi (messenger) came in with a message and saw his Excellency the Viceroy on the floor, forcing me to hold the mongoose so that it could see what was happening.

Sadly Neola never understood that lesson. He didn't really need to because the kitchens would provide fried eggs which we never were able to eat because as you raised your knife and fork there was a flurry of grey fur and a little weight on your lap for an instant as your egg disappeared. My father used to get so infuriated at never getting his fried egg that he would order the *kitmagar* not to put the fried egg down on the plate until he had his knife and fork at the ready and then he'd say 'go' and he still lost his egg every time. If it was boiled eggs and we had managed for some strange reason to actually eat our egg and there was a little left at the bottom in the shell, again there would be a flurry and Neola would arrive and grab the shell. But of course by grabbing the shell the bottom bit was in his mouth and the top bit was like a helmet covering his head so that he was blinded and ran round the room bumping into all the furniture.

Then there was the trouble of house-training the mongoose. My father said, 'Well I think we start him the way you do with a dog. If there's no chance of putting him where he should go, have some newspaper down and he can learn to go on the newspaper.'

My pony, Picolette.

E. with an odd group of servants who had came
to see her mount her horse

That worked very well. His puddles were very scrupulously done on newspaper. Unfortunately, early on, he did find papers on my father's desk which he used. They happened to be death warrants waiting to be signed.

Neola started by sleeping with me in my bed. But he was very small and he was alarmed if he thought I was going to turn over. So he bit very sharp needle teeth into my toes every time there was any sign of my moving. I reckoned that I'd really prefer a good night's sleep so eventually he was placed to sleep in a sort of special box and run we had made for him.

In the day, Neola liked to ride on my shoulder or round the back of my neck. I'd be inclined to wander around my room, not realising that Neola was on the furniture about to jump onto me and I'd move away and there would be a little thump on the ground behind me as Neola missed his landing stage. They're like dogs in that they love being in company and with people, but they're like cats in that they do not accept discipline, so Neola and I did have quite a few rows but there was nothing you could do to chastise a mongoose. If you used two fingers you squashed him flat. There'd be a row and then he would bring a peace offering and I'd be sitting reading a book and suddenly he'd jump up on my lap with it. Of course it was something like a cockroach and I hadn't the heart not to be very appreciative of the offering.

My parrot and my mother's dog were probably a nuisance for the servants who couldn't find a lowly enough sweeper to clear up after them. As Vicereine my mother once had a big dinner party for about sixty people. She was all dressed up in her long dress and her long white gloves and her jewels when she noticed that her dog Mizzen had had an accident in the corner. She said to her bearer, 'Oh look would you be kind, you see my dog has had an accident. Would you, could you, clear it up because I'm going in.' It was perfectly apparent to her that he was not going to clear the mess up. He said 'Lady Sahib, I will find someone.'

And nobody came and nobody came and nobody came. At least ten minutes went by. And of course they were unable to find somebody lowly enough to clear up a dog poo. My mother was so desperate that of course she got down on her knees and cleared it up herself.

The ADCs gave me my parrot, which they then stole back to have in a treasure hunt. He was called Eustace because he was so useless. He was one of the objects of the treasure hunt which annoyed me so much when I discovered what they'd done. After the treasure hunt, knowing that I would be annoyed, they thought they'd console the parrot by giving him cherries dipped in Drambuie, because they were all tipsy by then. The parrot was so drunk, he fell off his perch. Poor useless Eustace.

The mongoose was less of a problem because they are official pets – the only pets allowed in the jails. Nehru said he always had one when he was in prison and the wild ones would come in because they would be fed. As prisoners were allowed to keep mongooses in prison I think the staff assumed that even though we weren't in prison, we were allowed to have a mongoose.

After India

I have been fortunate in that many of my Indian friends continue to visit London, where I can see them. I returned to India three or four times with my mother. On one of these visits my mother and I were alone with Panditji when Dr Martin Luther King and his wife came to dinner. Dr King eagerly questioned Panditji about Mahatma Gandhi and I remember him saying what he thought Gandhi would have done if he had been alive on a recent occasion. Panditji gently pointed out that Gandhi would have been pragmatic and that he would probably have acted differently, to meet the demands of a situation arising ten years on in time. Another time we dined alone with him and Eartha Kitt.

I accompanied my father to the funeral of Panditji and then that of his successor, Shastri.

My father returned to India several times in his capacity as First Sea Lord and then as Chief of the Defence Staff and was delighted to accompany the present Prince of Wales on his first visit. When my father became Governor-General after Partition and the ruling Princes had acceded to either India or Pakistan, he encouraged them to offer their services to the new Heads of Government. The Maharaja of Jaipur became Ambassador to Spain and then Rajpramukh of Rajastan.

A couple of years after I married David Hicks in 1960, we went to stay with Panditji. We also stayed with Bob, the new young Maharana of Udaipur while Jackie Kennedy and her sister, Lee Radziwill, were there. As a designer, David was inspired by the colours of India, the colonial architecture of Calcutta and Lutyens' masterpiece, Viceroy's House with its incredible Moghul Gardens.

My daughter India first went there backpacking with her cousin Timothy. They visited Bangalore and I suggested she go and see V.P. Menon's daughter, Menakshi. As she was saying goodbye, India asked if she would be seeing her in Delhi. Menakshi replied, 'Why did your mother not come with you?' India answered, 'She told me that she was too busy and that she couldn't leave my father.' Menakshi said, 'And you believed her? No, no your mother and I are snobs. She didn't come for the same reason that I never go to Delhi. We lived there while history was being made. We lived incredible lives. We don't want to spoil that memory.'

Author's Note

This book has been created from my diaries and letters written in India, and from interviews and notes I have given or written since that time. I have also looked occasionally to my parents diaries to give a more three dimensional perspective on our time in India, as well as quoting once or twice from letters written to my sister Patricia. My father was a meticulous diary writer and note taker – the fact that he did so and encouraged us to do the same means that this book exists. Our family photograph albums also provide the wonderful captions to many of the pictures and are now kept in the Broadlands Collection at Southampton University. Many of those legends in his own hand are reproduced here in facsimile.

Of course, when things got exciting it was difficult and sometimes impossible to keep the diary as up to date as it should have been, it is therefore, with grateful thanks, that I have on more than one occasion looked to the daily recordings of Alan Campbell-Johnson (*Mission With Mountbatten*, Atheneum, 1951) to remind me of the goings on at that time – especially during the period that we were travelling at the end of 1947 and the beginning of 1948.

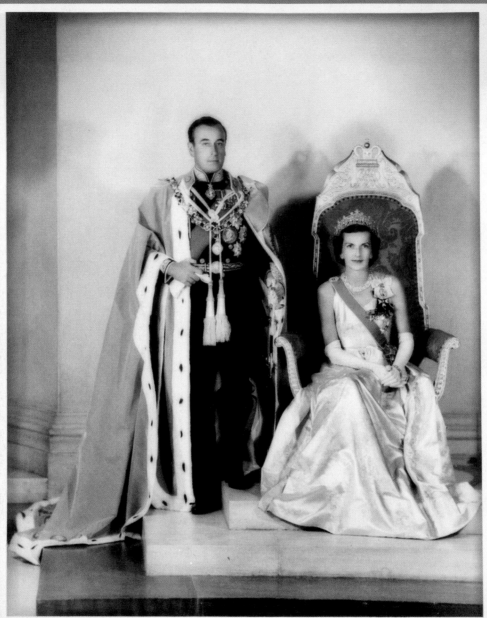

Daddy Mummy Kinsey

1948
INDIA

Part I

The Last Viceroy of India

Chronology of Events

20th March 1947	Mountbatten, Edwina and Pamela travel to India to take up residence in Viceroy's House.
24th March	Swearing-in of the new Viceroy. Mountbatten begins his informal meetings with all the key players in India, including Gandhi, Nehru and Jinnah.
15th – 16th April	Governors' Conference at Viceroy's House.
28th April	Mountbatten and Edwina confront the Muslim League demonstration during a visit to Peshawar.
30th April – 2nd May	Edwina tours riot areas and refugee camps.
3rd May	Mountbattens visit The Retreat at Mashobra, Simla.
14th May	Mountbattens return to Delhi.
18th May	Mountbatten flies to London for discussions with the Government and Opposition, following Nehru's rejection of the original Plan.
1st June	Mountbatten back from London.
2nd June	Conference at Viceroy's House to determine the details of the Plan.
3rd June	Agreement reached by all parties and administrative consequences discussed. Announcement made on All India Radio.
4th June	Press conference indicating 15th August as date for transfer of power: the countdown begins.
18th July	Parliament pass the Indian Independence Act.
25th July	Mountbatten tries to persuade the Chamber of Princes to accede to India or Pakistan before Partition.
14th August	Independence ceremony takes place in Karachi, Pakistan with Mountbattens present, who then fly back to Delhi for the Indian independence ceremonies. Just before midnight Mountbatten formally invited to act as India's first Governor-General.

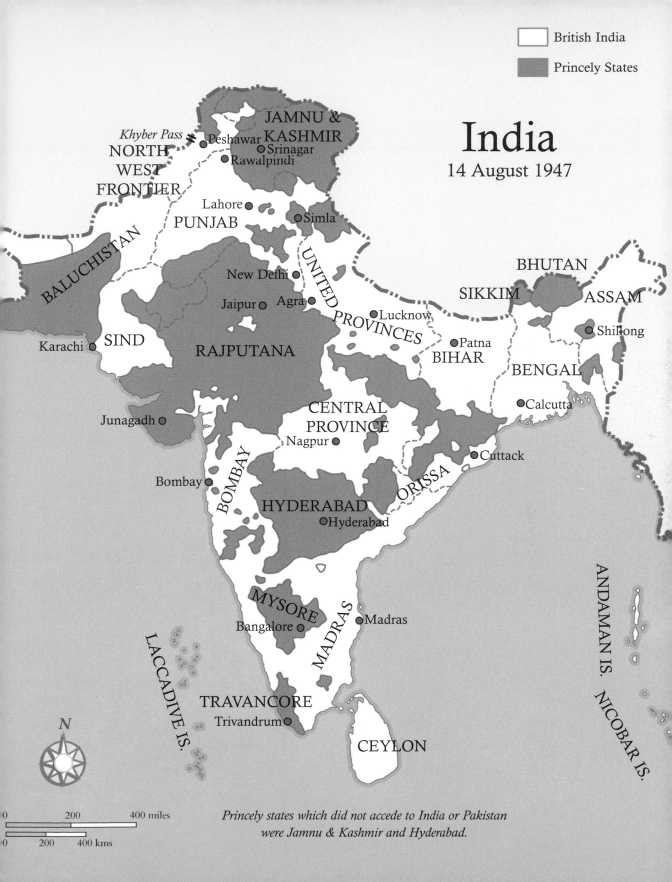

India
14 August 1947

Khyber Pass

NORTH WEST FRONTIER

JAMNU & KASHMIR

Peshawar

Srinagar

Rawalpindi

Lahore

PUNJAB

Simla

BALUCHISTAN

SIND

Karachi

Jaipur

New Delhi

Agra

UNITED PROVINCES

Lucknow

RAJPUTANA

Patna

BIHAR

SIKKIM

BHUTAN

ASSAM

Shillong

BENGAL

Calcutta

Junagadh

CENTRAL PROVINCE

Nagpur

Cuttack

BOMBAY

Bombay

HYDERABAD

Hyderabad

ORISSA

ANDAMAN IS.

MYSORE

Bangalore

MADRAS

Madras

NICOBAR IS.

LACCADIVE IS.

TRAVANCORE

Trivandrum

CEYLON

N

0 200 400 miles

0 200 400 kms

Princely states which did not accede to India or Pakistan
were Jamnu & Kashmir and Hyderabad.

*22nd March 1947: With the Viceroy and Lady Wavell watching my parents
arrive in a horse-drawn carriage escorted by the Bodyguard.*

First Impressions:
March 1947

'Of course, to arrive and to live in a house like Viceroy's House . . . in a way it was completely the end of one's small family circle and private life.'

(From an interview with the author by the Nehru Memorial Museum.)

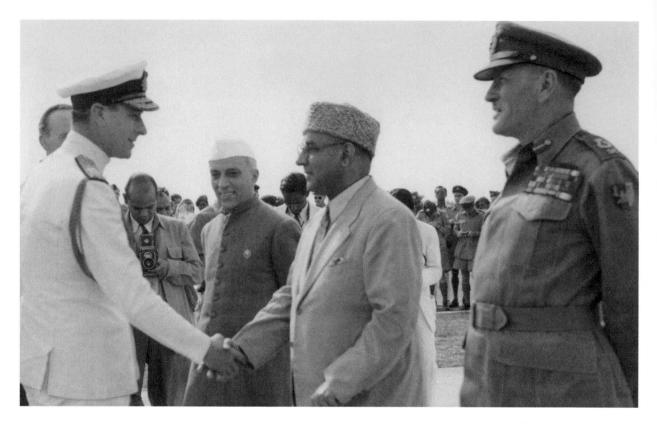

22nd. Arrival at Palam Airfield and being received by Nehru, Liaquat Ali Khan and Auchinleck

Arrival in Delhi

My first impression was of heat and jumble. I had to concentrate on being good – hat uncomfortable, ditto gloves. In those days, wherever you were flying in the heat, you would get these air pockets and there was no pressurisation in the cabin. So, if you got bad weather you would bump and drop, and if you were me you were sick. But, as you got out of the plane, with a dozen photographers waiting, you were not allowed to look green. It was really the concentration of trying to do what one was

22nd March: Standing to attention as the National Anthem plays on our arrival.

supposed to be doing and to be where one was supposed to be and how hot one's little white gloves were and how the hat was so uncomfortable. One had no real sense of the excitement of actually having arrived in India; it was all worry, worry, worry and the dust, and had the dust covered one's face, and if so, should one get one's handkerchief out?

Saturday 22nd March
We arrived at Karachi in the morning to be met with terrific guards of honour and numerous people tearing round... We flew on and had a very bumpy trip and landed at Delhi feeling quite frightful. Met HE and

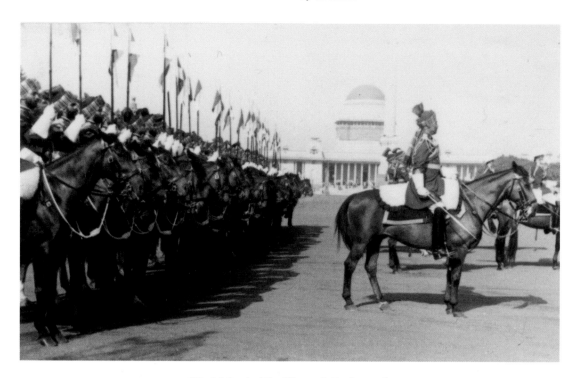

22nd March: The Viceroy's Bodyguard.

Her Ex, saw Mummy and Daddy arrive complete with carriage and had
dinner with Felicity and her husband and brother.

On arrival I remember the dismounted Sikh Bodyguard in
turbans on each step of that enormous flight of very, very wide,
imposing steps up to the house. All the Sikhs in their turbans
looked magnificent with their lances and the bagpipes of the
Royal Scots Fusiliers playing. Of course, having to curtsey to
the Viceroy and Vicereine on arrival at the top wasn't difficult
because, at that time, most of one's relations needed curtseys
anyway, but one always had to worry that one did it properly.

We only had one evening to discuss matters with the Wavells,
the outgoing Viceroy and Vicereine. Felicity Wavell brought me all
her files and told me, 'the Viceroy's House compound has 555

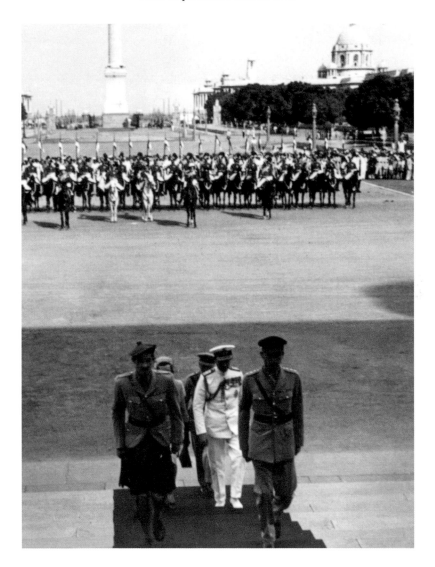

22nd March: Entering Viceroy's House.
Bodyguard drawn up after escorting us.

servants, so, with their families, there will be several thousand, and
we have a school, and you will have to be the chief visitor for the
school. And there is a clinic... Oh, it has a whole community and
the office of the Vicereine hardly has time to do that, so it will be

your duty.' So one really did find oneself in at the deep end. My mother's Quaker friends in London had advised us who we should contact. They had done a lot of work in India, particularly when the leaders were put into prison. My mother was keen to meet all of the influential women in India. I was given the names of all the student leaders who were in prison at that moment, but who were about to be released. When we were in Bombay or Calcutta, I would have to make contact with them.

Sunday 23rd March
We went to the airfield and saw all the Wavell party off. It must have been a great wrench for everyone to suddenly be forced to change over like that.

The Swearing-in Ceremony

'The film cameras whirred and the flash-bulbs went off for the first time in the confines of the Durbar Hall.' *Alan Campbell-Johnson*

My mother's dress had been made in England. And my father wore the full dress white naval uniform. They both looked like film stars – very, very handsome, both of them. Of course there was no hairdresser so my mother had to do all of that kind of thing herself.

Monday 24th March
The numerous arguments as to what was fitting resulted in Daddy wearing full dress whites and Mummy a simple, long white dress with decorations but no jewellery. It will take a lot of getting used to seeing them sitting on thrones and dropping curtseys to them etc, but it can't be nearly as trying

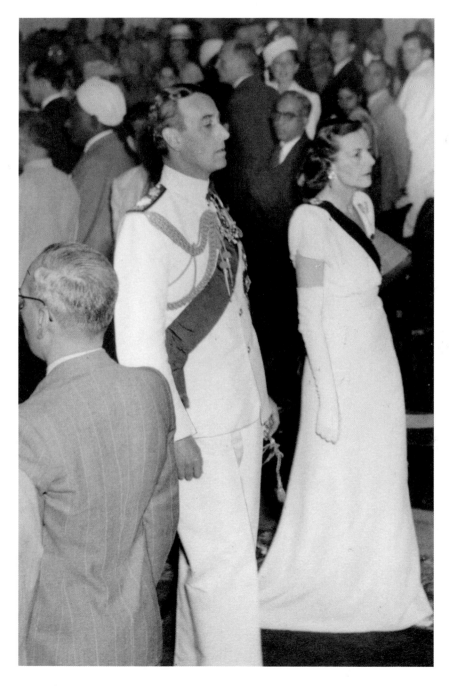

24th March: Processing out of Durbar Hall after the swearing-in ceremony.

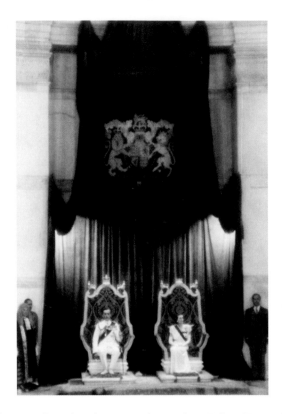

24th March: Seated on the Thrones in the Durbar Hall in Viceroy's House.

as it is for them, but after looking slightly glazed to begin with they seem to be bearing up quite well.

Alan Campbell-Johnson describes the scene:
'...trumpets from the roof acting as a shattering prelude...
Mountbatten himself looked superb with the dark-blue ribbon of Knight of the Garter and the overwhelming array of orders and decorations across his chest... Lady Mountbatten... was the epitome of grace, with her new order of the Crown of India, besides all her war medals and other decorations, on her dress. The red-and-gold thrones were set in bold relief by the lighting concealed in the rich red velvet hangings.'

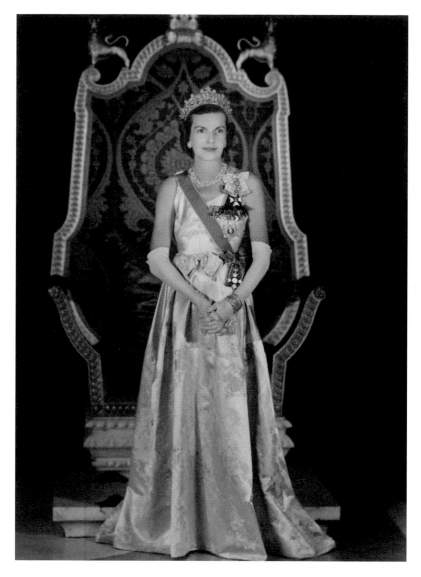

Official portrait of my mother as Vicereine.

This reminds me of a nice piece of romantic family history.
In the 1930s, my mother and a friend of my parents, Yola
Letellier, were in Paris at a big ball. One of the attractions was a
fortune teller who was the rage of Paris. Every chic person wanted

to have their fortune told, except for my mother who thought it was nonsense. But, Yola was very insistent and said, 'No, no, no, Edwina, you must, you must, everybody's having it done.' In fact, it would have been rude not to agree, so they both giggled their way over to her. But when she had her fortune told my mother knew it had to be nonsense because the woman said to her, 'I see you sitting on a throne, but it's not an ordinary throne, there's something strange about it, but you are sitting on a throne nonetheless…'

The House

I described Viceroy's House in those first diary entries in India as 'absolutely immense, presumably quite impressive just to come and see and go away again, but a complete headache to live in and it seems to have been built for the express purpose of losing people in'. It was enormous with high ceilings: it took ten minutes to walk from your bedroom to the dining room – by bicycle was often quicker.

My mother set out immediately to understand everything about the house, the estate and the servants at a rate which astonished the Comptroller. No detail was left unexamined or unquestioned: the timing and cost of meals, the state of the servants' quarters, the condition of the linen and plate, the management of the house, the gardens, the stables, the school, the clinic, and I would most often accompany her:

Tuesday 25th March
I went on a tour of the house with Mummy which entailed walking for well over two hours!
Our present rooms are very nice and we hope to keep them until they become really too hot when we shall have to move over to the other side.

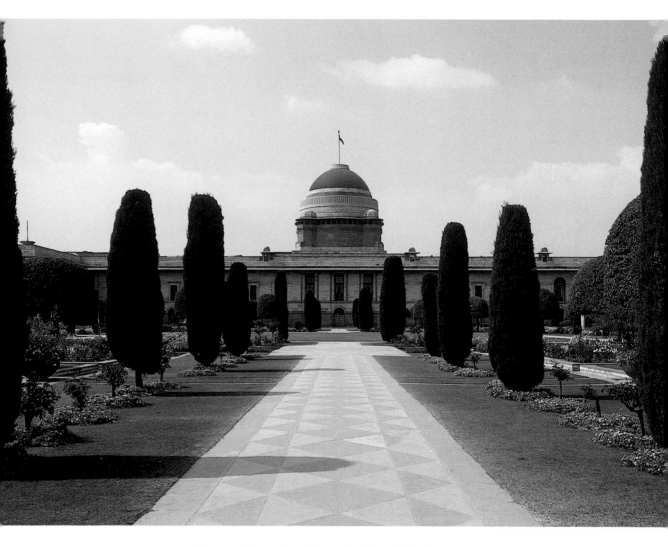

Viceroy's House viewed from the Moghul Gardens.

Thursday 27th March
Although the house is so immense, the accommodation is completely
inadequate as the entire plan seems to make no sense whatever but just
consists of vast corridors leading nowhere. There is a lovely swimming
pool though and we bathed yesterday and had lunch out there today.

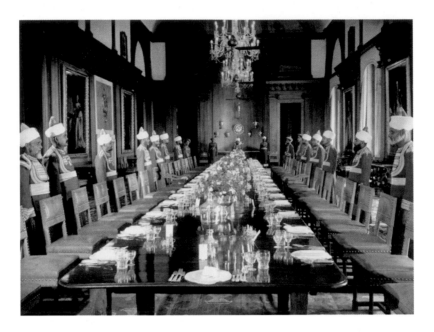

State Dining Room (above); Durbar Hall (right).

I soon became aware that Viceroy's House was like a hotel in which you hardly ever saw any other guests who might be staying there – and there were often guests. My sister Patricia had accompanied my father in 1946 when she was in the Wrens, and had been asked to stay on by the ADCs. When she had protested that she had not been invited by the Viceroy she was told that the house was so big that no one would ever bump into her!

Later in the 1960s I accompanied my father on a visit to India and we stayed in what was now President's House. As we were saying goodbye to our host, the King and Queen of Afghanistan and their party also arrived to say farewell. They too had been staying in the house for a week, but we had not even known they were there.

The house was 'not exactly cosy', as I described it in a letter to a friend: 'I was continuously getting hopelessly lost, and swarms of servants and endless cocktail parties and people to meals and

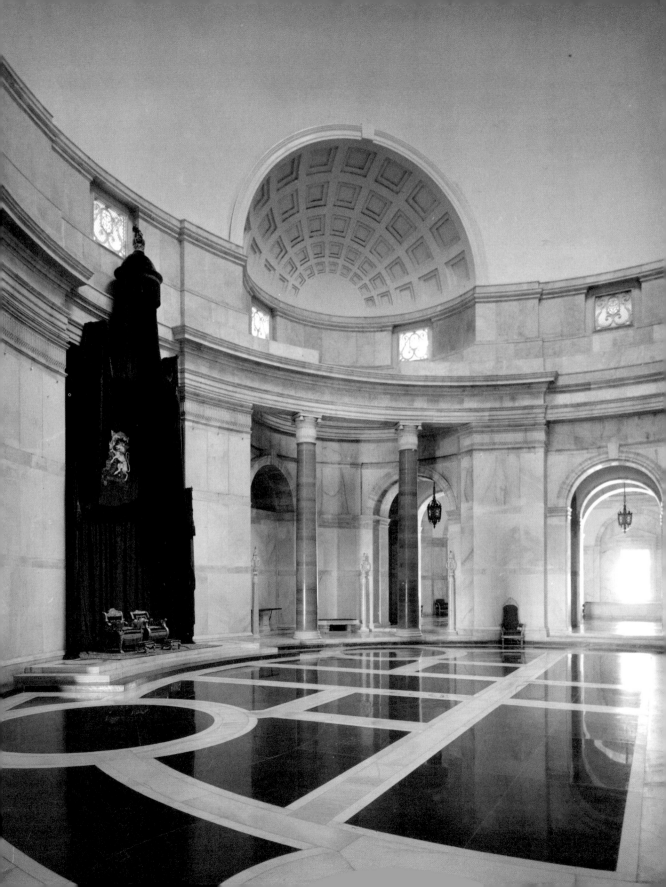

the terrible Walkie-Talkie system by which people are brought up
to talk to one when one hasn't a clue as to who they are, and the
moment the conversation gets beyond the weather preliminaries
they are removed and one has to start all over again with another
unknown body, but luckily even the etiquette is generally relieved
by being faintly ridiculous and amusing!' If you did not bump
into your guests or family you were never alone: 'one can't
exactly take a book and find a quiet corner as there just isn't such
a thing and swarms of people are liable to appear from behind
every bush! Even with the very reduced staff, if one includes all
the people in the estate plus their families there are five thousand
attached to the house!!'

The Servants

When Felicity Wavell told me that as the Viceroy's daughter
I would inherit her bearer – Lila Nand – I was horrified, I hadn't
even had a lady's maid, let alone a male.

Tuesday 25th March
I have been given Felicity's bearer, Lila Nand, who is quite charming and
very good but at the moment it is harder to get used to telling someone
what to do than do it oneself, but apparently the latter is out of the question.

Lila Nand was initially extremely disappointed with me, but
trained me quite well. He kept on saying, 'Oh, of course one of
previous Viceroy's daughters, she much better, she beat me.'
When I protested, 'Lila Nand I'm not going to beat you,' he
simply said 'Oh, Viceroy daughter should!'
We did get on very well but the most tragic thing happened
when we left; about three months before our departure his son died
– he was only a small boy of about seven. Lila Nand also had a

little girl of about ten and a sweet wife. He was naturally distraught and so I was trying to comfort him, with all of my eighteen years experience, saying things like, 'Lila Nand, you and your wife will probably have another baby and maybe it will be a boy and you've got this lovely little girl and you're young...' He couldn't have been more than forty. 'You know, you will have all your married life ahead of you.' 'No, no, no Miss Sahib, I die, I die.' When we left I was worried and really very fond of him, so back in England I sent a message out asking how Lila Nand was and the answer came back from his brother, Amla Nand, 'Oh Lila Nand, he died.' He had been in perfect health, but he was so distraught he had turned his face to the wall and willed himself dead.

Daily Routine

My father and I would ride every morning at 6:30am on the ridge above Delhi with a couple of armed bodyguards. Then we would have a family breakfast together if possible, when my mother was not rushing off to see refugee camps and riot devastation, and then meetings began at 10am – or at least that is how things were organised to begin with. We had a very hectic social diary on top of my parents' work. And with my parents' emphasis on an open and approachable policy for Viceroy's House, each week we gave two garden parties; three or four lunches for about thirty people and two or three larger dinners at which the mix of guests had to be, at my father's insistence, at least fifty per cent Indian.

My father was very aware that his wife and daughter could help enormously with his work by socialising and mixing with his contacts and their families; our diaries are therefore litanies of social events:

Overleaf: The family with the Domestic Staff in December 1947.

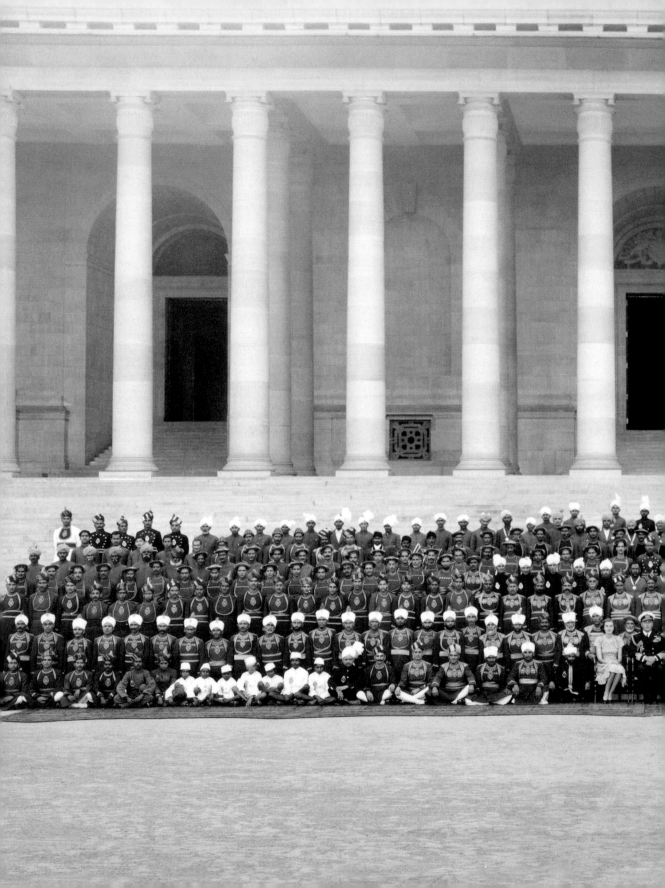

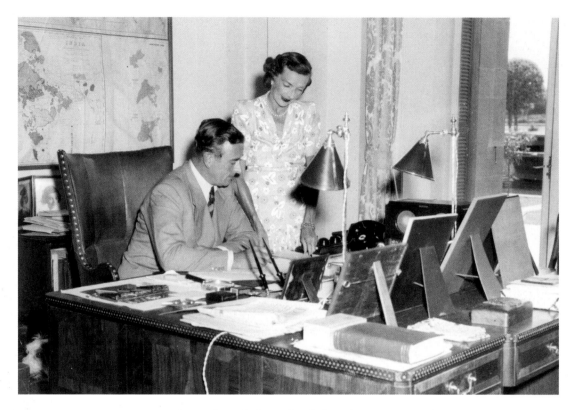

My mother with my father at his desk in the Viceroy's study.

Friday 28th March
I went down for dinner and then we went on to a party given by Pandit Nehru for the delegates and saw some dancing displays. I met Nehru's daughter, Mrs Gandhi, his niece Lekha and her mother Mrs Pandit, who Miss Lankester wanted me to contact.

Saturday 29th March
I went with Mummy to a reception at the Lady Irwin College given by the All India Women's Conference for all the women delegates of the Inter Asian Conference. Being already rather dark and having got separated from Mummy, everyone seemed convinced that I was the Palestinian delegate.

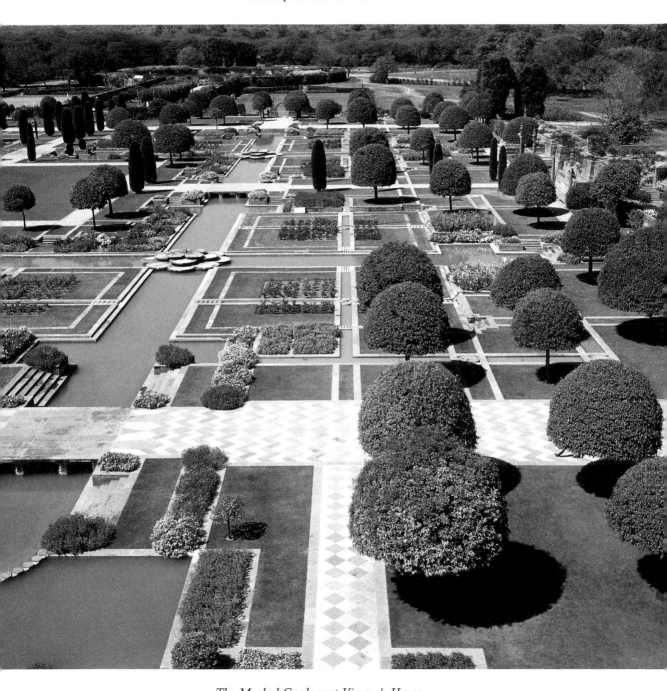

The Moghul Gardens at Viceroy's House.

Monday 31st March
We had a big and very tedious lunch party and I sat next to the
Maharajah of Kapurthala who asked me what we had been able
to go and see, very awkward as one of his wives has just committed
suicide off the Qutb Minar. [This was a 13th century tower that my
parents had found time to take me to see.]

Saturday 5th April
We had a big lunch party including Pandit Nehru and the Indonesian
premier, Mr Sjahrir who has just arrived. I sat next to Mr Krishna
Menon, Nehru's representative in Europe and in manners far more
English than any Englishman.

Saturday 12th April
…had another enormous garden party.

Mountbatten's Study

This was the epicentre of my father's first few weeks in India.
It was the place he would receive people.

If you were going to see him for a meeting, you'd be driven
up to the front of the house, through the sentries who would be
rather decorative. Then there would be security in khaki behind
them with a revolver at the ready and the police would have a list
of people expected. You were driven up to the north courtyard,
where the Aides de Camp (ADC) room was, and an ADC would
come out and greet you. If it was a business meeting, there was
ADC1 to greet you – they took it in turns. ADC1 was for the
Viceroy, ADC2 was for the Vicereine, ADC3 was guests. Or if
I had something very special, ADC3 would do me as well. But it
was really guests. You then went in a side door where again there
was a secretary who would take you through to my father's study.

It overlooked the Moghul Gardens, so he and his guests could easily walk into them during or after a meeting.

The Moghul Gardens

'The gardens, although rather too terrific, are looking perfectly lovely now,' I wrote. After we arrived, Mr Reader, the head gardener, duly attended my mother and asked if there were any orders about the gardens. They were world famous – and still are, they're kept exactly the same to this day. My mother knew very little, unlike Lady Willingdon who had taken a great interest in the gardens. So she just said, 'Carry on, you're the expert.'

Unfortunately we were going to have a big Asian relations conference and we were also expecting a Tibetan delegation on the 1st April, but because Mr Reader knew nothing of these plans and presumably hadn't actually consulted the ADCs who must have known about the events, when we wanted to step out for a garden party all the turf had been rolled up and taken away.

The Heat

If the huge house, the hectic entertainment schedule, the hundreds of servants, the political issues surrounding us, and the list of contacts we had to meet weren't enough to contend with, there was also the omnipresent heat. Having left the coldest English winter on record we now found ourselves in the hottest weather Delhi had experienced for seventy-five years. Of course at this season the Viceregal entourage would retire to the cool hills of Simla with the rest of the British, but we could not afford this luxury. There simply wasn't a moment to lose, so we stayed down in the furnace.

Thursday 3rd April
Most of the shops are already closing and moving up to Simla and really only the barest necessities seem to remain for the few who stay down during the hot weather.

Monday 7th April
We moved our rooms, changing into the opposite wing as in the hot weather it is almost impossible to live permanently on the south side. It is also almost impossible to live on the top floor under the roof. As we have a large indoor staff and the house consists entirely of immense passages but very few bedrooms, it makes the question of accommodation an absolute nightmare.

Delhi

During our first few weeks we had very little time to explore our surroundings but I did see a little as I wrote to my friend Mary: 'Delhi itself is an extraordinary place. New Delhi with all the government buildings, army headquarters, the Secretariat and Viceroy's House has only been built over the last twenty years. It all runs according to plan with great vistas and arches, parks and roundabouts and looks lovely at night with some of the buildings lit up, but it is so spacious that it loses all atmosphere and the people themselves, as so often seems the case in capital cities, are very artificial. But it is much more fun now with all the foreign representatives coming in and amongst the Americans, Chinese, French, Dutch, Belgians and Afghanistanis etc there are one or two girls from about sixteen to thirty who really are extremely nice.

Old Delhi, on the other hand, is first what one imagines, colourful, crowded, smelly but fascinating and complete in atmosphere. It merges into the new City but even then it is

1st April: The Tibetan delegation at Viceroy's House. They were very brisk in dispensing their gifts of white scarves and gold dust because they were anxious to get to the Delhi races on time.

about eight miles from where we live at the other end so one can't just walk into it which is a pity.'

We had little time to accustom ourselves to our new lives as immense problems were waiting to be solved.

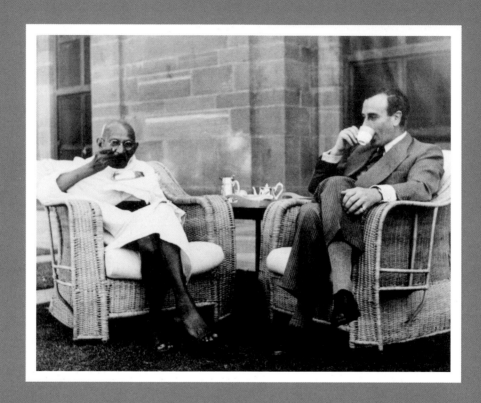

1st April Gandhi's "First Ever" Meal taken at
Viceroy's House

A Huge Task: March – April 1947

Within a couple of days we met Mahatma Gandhi and Pandit Nehru. When my father was in India with the Prince of Wales in 1921 Gandhi had secretly been arrested. My father had been keen for the Prince of Wales to meet him. But my father was a brash 21-year-old and much the most junior member of the staff so his suggestion came to nothing. When he finally met him in 1947 he felt it was a very special occasion.

Operation Seduction

Before we had flown out to India, my father had already worked out that if he was to hit the ground running he would need to meet the four most important personalities behind the opposing political ideas. He had already contacted Mahatma Gandhi and Jawaharlal Nehru before he arrived, and he then invited Mr Jinnah and Vallabhbhai Patel. They were about to have a charm offensive unleashed upon them – one of my father's disarming tools before he would launch in with his pragmatic strategies for movement and solution.

> 'The situation is everywhere electric...
> the mine may go up at any moment. If we
> do not make up our minds in the next two
> months... there will be pandemonium.'
> *Lord Ismay March 1947*

Monday 31st March
Mr Gandhi came to talk to Daddy and I went in with Mummy to meet him. He really is a remarkable old man and a great character. Crowds of his hangers-on swarmed about outside the house all the afternoon. Intending to come for an hour he stayed for two and a half.

Tuesday 1st April
Mr Gandhi arrived at nine to walk round the gardens before resuming his talk with Daddy. He had his breakfast during their discussions, apparently a unique honour for us for him to eat before an Englishman.

Right: Gandhi's first visit to Viceroy's House.

31st March Symbolic gesture
of Friendship by Gandhi

It was important to meet Gandhiji as soon as possible because he was 'Bapu': the Father of the Nation. All the impetus for the 'Quit India' programme had been his and Motilial Nehru's, Nehru's father. They were the older, wiser generation and the others were considered youngsters, although they were all over fifty years old at this time.

> 'Gandhi will be seen by history as on
> a par with Christ and Buddha.'
> *Louis Mountbatten 1948*

Gandhi was Nehru's mentor. For the servants at Viceroy's House, Gandhi's visit was like God and royalty walking in together and they would bow and fall to the ground, such was his importance to them.

Growing up in England, we had heard a lot about him. I'm afraid the ignorant English take on him was 'a funny little man in a loincloth.' In fact, he did wear his shawl to come to Viceroy's House, I think largely because it wasn't yet that hot although it was the beginning of March, but also my father's study was air-conditioned and quite cool. After the initial photographs of the three of them outside the house, as they turned to go in, Gandhi put his hand on my mother's shoulder, because he was quite frail and quite old. He was so used to his great niece, one of his 'crutches', always being there that he'd always have a hand on one of these girls for support. So instinctively he put his hand for support on my mother's shoulder. This would have been welcomed by my mother of course, but sadly this photograph caused real outrage in England when it was seen. They thought it was not appropriate at all that this 'black hand should be placed on this white shoulder.'

The next day, Gandhiji made a great concession to eat his habitual goat curds at Viceroy's House with the Viceroy.

He offered it to my father, who politely tried to refuse and then Gandhiji, with a lovely mischievous smile, insisted. My father said it was the most disgusting green porridge that he'd ever had.

Jawaharlal Nehru

It was important that my father spoke with Nehru early because he, with Vallabhbhai Patel, led the Indian Congress Party. He was a Kashmiri Brahmin but spoke, and wrote beautiful English (much better than our own – he was educated at Harrow and Cambridge). He was such a civilised person and such fun, and was the one person that the future of India depended on.

I suppose the first time I met him I would not have dared call him Panditji, that came later as we got to know him; it would have been Mr Nehru. I was nervous. My parents had met him before of course. He and Gandhiji were obviously the key figures in the whole situation. It is a great moment to meet such an important man, and how very often it is a terrible disappointment. You expect so much, having heard so much, especially when you are about seventeen. It is shattering if they behave in a normal way. One is terribly disillusioned. But with Panditji, it could never be a disappointment, because he had such charm. I have no idea what he said to me except that we just shook hands and he said 'How do you do?' But to shake hands with Panditji and to be smiled at by him was something very special. He had such tremendous warmth and you really felt that he was delighted to meet you, and particularly, I think, young people always felt this with him. His air was far from patronising, there was no condescension. You just felt that he, and Gandhiji, were the most special people you were ever likely to meet.

Right: This portrait was given to me by Nehru. The inscription reads 'Pammy, from Mamu 1948.'

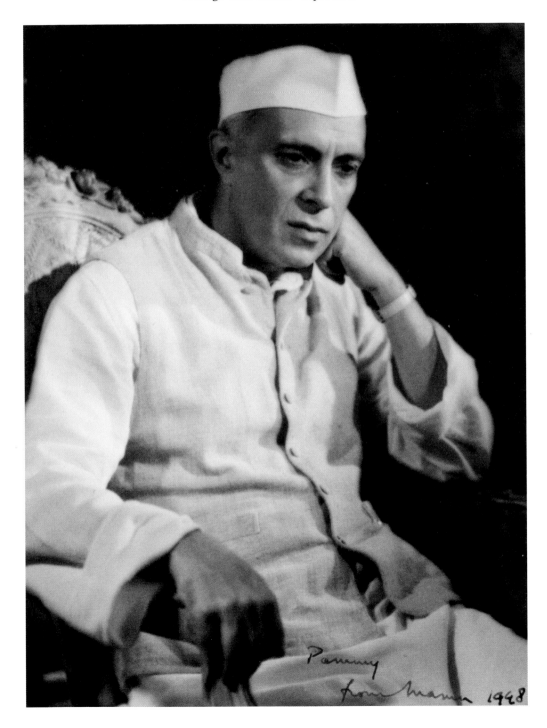

Panditji was seldom aloof with us. But he was definitely a person who went into great silences and one would never have thoughtlessly intruded upon or interrupted him at that moment. One felt that he was wrestling with problems and wanted to be alone. But then, an hour later, he had changed. He would have resolved the problem he was struggling with and he would have that enormous charm again. This was typical of the speed with which his moods could change. He could lose his temper so quickly. I remember one day too many people gave my parents autograph books to sign, the crowd was overbearing, thrusting them in their faces and he became impassioned and took all the autograph books and threw them in the air. My mother was very shocked, but he had a wonderful way of putting his arm around one's shoulders and giving one a hug and everything seemed fine.

Panditji was one of the wisest people I have ever met. You know the kind of intolerant remark one would make at seventeen or eighteen when one thinks one knows the solutions to the world's problems. I sat next to him once at one of the big dinners at Viceroy's House. I was getting very indignant about the behaviour of the 'Pukka Sahib' sort of British in India and I was saying, 'But it's terrible, how can they behave like this?' and Panditji just looked at me and said, 'Oh, I should not get so excited about it. When I go to England I am always mortified by the behaviour of the Indians. You will always find that people out of their own country appear to least advantage: it happens all the world over.' He never would allow one to get away with making a silly remark.

Another time when I sat next to him at dinner, we talked about my mongoose. Panditji was telling me that when he was in prison the mongooses were always very popular. This led to me say how dreadful it must have been for him to have been imprisoned for so many years. He acknowledged that it was

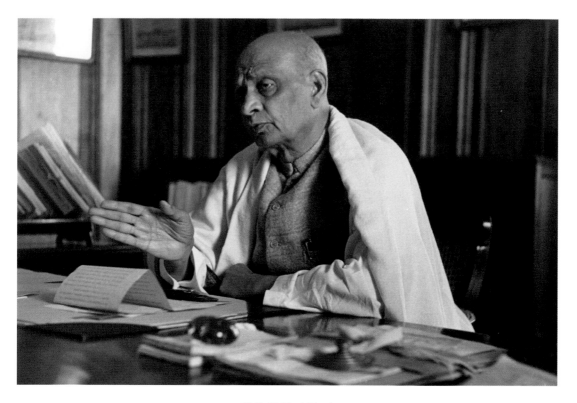

Vallabhbhai Patel.

frustrating not to be able to have access to all the reference books he would have liked when writing *The Discovery of India* and *Glimpses of World History* but that the good thing about prison was that it gave one time to think and everyone needs time to think. He added, with a smile, 'It would do you good to be in prison for a while.' I was amazed that he showed no bitterness. But Gandhiji had taught that the struggle was against the Raj, and not the people. Those who suffered terms of imprisonment without trial for anything from ten to twenty years with their families and children, could yet come to Viceroy's House and all it stood for with no trace of bitterness, and be prepared to extend true friendship. It is a particularly wonderful part of the Indian character.

Vallabhbhai Patel

Patel, Nehru's Congress colleague, on the other hand, was a hard
trade union man. He was pragmatic and tough. When Nehru,
the urbane idealist, would go off at a passionate tangent, Patel
would say 'Don't go ahead of the people so far, come back,
take them with you.' They were a very good team. He too
was a disciple of Gandhiji. He had worked with him in 1922
organising civil disobedience and had risen through the ranks
of Congress since then to become a respected leader.

I remember a funny incident with this severe man at lunch
one day. My mother was forever taking her shoes off under
the table because she had quite high heels. And Vallabhbhai had
taken his sandals off and we could see that she and he were
chuckling. Lots of chuckling was going on and of course he
was trying to get her shoes on and she was trying to get his
sandals on.

Mohammed Ali Jinnah

Mr Jinnah – my father rarely called him anything else – was a
fastidious man. He was extremely sophisticated and unlike the
other Indian leaders always dressed in an immaculate English
style rather than national dress. He was a Muslim but only spoke
in English, which he spoke perfectly, whenever he condescended
to speak. He had been intent on creating Pakistan ever since
he had been introduced to the concept at the history-shaping
meeting in the Waldorf in London in 1933.

He did not fall for my father's charm offensive in those first
days – which must have been working at full power. I was
obviously ousted when the going got tough as my diary entry
for 6th April says, 'I had dinner with the ADCs as Jinnah and

5th April: First meeting with Jinnah. 'A rose between two thorns.'

his sister came to talk business.' At first my parents were very optimistic about the chance to mediate between Nehru and Congress, and Jinnah and the Muslim League. As my mother wrote in her diary of that same evening, 'Fascinating evening, two very clever and queer people. I rather liked them but found them fanatical on their Pakistan and quite impractical.' Within a few meetings this optimism lapsed.

My father could talk of nothing else because he could not crack Jinnah and this had *never* happened to him before. He later admitted that he didn't realise how impossible his task was going to be until he met Jinnah. He has since often been accused of being anti-Muslim league but that was not the right way of

looking at the problem – Congress made themselves open to my father and courted his help. Jinnah was the opposite and rejected my father's involvement whenever he could.

Of course the famous story of Jinnah's first meeting with my parents was about the comment that backfired at their photo-shoot. Jinnah was meticulous and would have prepared a joke – presumably, of course, it was delivered before they were posed: as he had assumed that my mother would be photographed between him and my father, when asked to pose he said, 'Ah – a rose between two thorns.' Unfortunately it was he who was placed in the middle of the composition and not my mother.

It became perfectly apparent once my father had met all four leaders and taken on board their views (and the intransigence of Mr Jinnah), that there was no way they were going to be able to keep peace while this impasse remained and that it was vital to transfer power as quickly as possible so that the various leaders could make their own decisions. If they were still in waiting, nothing would get done because everything needed their approval. If they were in power themselves, then decisions could be taken more quickly.

The Governors' Conference

The Governors arrived at the conference from all over India to give their first-hand reports to my father of the situation on the ground. Their reports made depressing reading. They came from Bombay, Madras, Punjab, Sind, the United Provinces, Bihar, Orissa, Assam, Central Province, the North Western Frontier – only the Governor of Bengal was missing through illness. Apart from Assam, whose report was comparatively benign, my father learned from Sir Evan Jenkins that the Punjab situation was critical; from Bengal's report, that there was great agitation; and

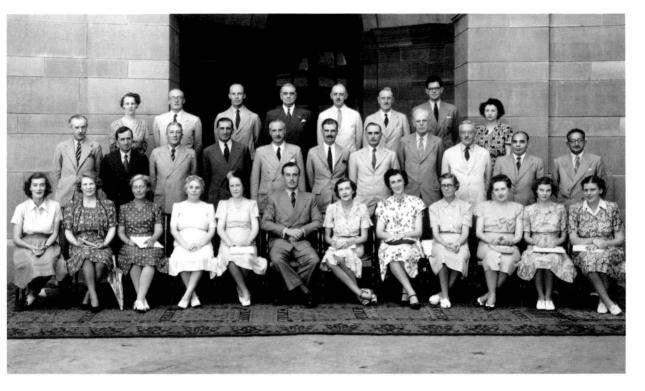

16th April: All India Governors' Conference – the Governors and their wives.

from Sir Olaf Caroe, who Campbell-Johnson recorded as 'tense and tired', that the NWFP was on the point of crisis.

Monday 14th April
Through the day Governors and their wives arrived to stay for
conferences. The muddle over who an HE referred to was appalling and
they were all very apt to try to swoop through doorways first! Some of
them were really very sweet but two of the wives have already fought
like cats and dogs much to everyone's enjoyment.
I went with Mummy to see the Allied Forces Canteen, Felicity used
to work there sometimes and I am going to try to also.
Mr Krishna Menon has sent me a signed copy of Pandit Nehru's book
The Discovery of India *which is rather exciting.*

The conference started on the 15th my mother corralled the Governors' wives into a conference of their own – with little exception she was shocked and disappointed in how little they knew or had been involved in the crisis.

> 'Even the quieter provinces feel that we
> are sitting on the edge of a volcano.'
> *Mountbatten's report after the conference*

My parents had been brought up to have a very inclusive and international attitude to society which is why we found it easy to embrace Indian life so quickly. Not so with some others.

Tuesday 15th April
I went to the most extraordinary cocktail party given by Lady Tymms full of horrifying specimens and swarms of the huntin', shootin' and fishin' type who bombarded me with indignant demands as to why I hadn't been out with hounds every morning since my arrival?!

Wednesday 16th April
…hauled back from swimming pool after lunch for a group photograph taken with the Governors and Governors' wives, and all of us looking as silly as in any group photograph.

Thursday 17th April
The three Indian ADCs have arrived and seem very nice and quite unimpressed by the general turmoil!

My mother, having appraised the house and the staff, now invested her attention in understanding and going about improving conditions where she could on the Estate.

Friday 18th April
I went with Mummy to see the primary school on the Estate.

Saturday 19th April
It sounds very important but rather alarming being eighteen. I was thoroughly spoilt and given the most wonderful presents including a miniature Star of India from Daddy, very exciting and the only one in existence, and also a most extraordinary but rather intoxicating parrot by the ADCs.

Sunday 20th April
The most awful part of one's time is spent in writing these wretched diaries. All of us, except Daddy, have it perpetually hanging over us and yet the moment one gives up one regrets it!

Monday 21st April
We gave a garden party for all those on the Viceregal establishment. We were about four hundred but that did not include any of the three hundred and fifty indoor servants or any of the PW-W [the Public Works Department], *merely the various heads of the departments. There are something like seven thousand people living on the Estate connected with the Establishment.*

Tuesday 22nd April
I went all round the Bodyguard with Paddy Massey and saw all the horses, the carriages, cattle, classrooms, and in fact the entire establishment and it really was fascinating. At the moment in its much reduced state, it consists of about one hundred and twenty men and sixty-three horses. They really are the most magnificent sight in their full regalia.

Wednesday 23rd April
I went with Mummy to see the Wavell Canteen which serves the troops

passing through the railway station in transit. We also went to Auchinlock Auamgah which is the corresponding canteen for the Indian troops. Indians are theoretically provided for in both the Allied and Wavell Canteens but their pay is not sufficient to compete with centres for the other troops.

Friday 25th April
I went with Mummy to see the quarters of the families of the bodyguard officers and linesmen, the clinic and the dispensary. All the women were in purdah (which luckily got rid of all our procession!). Their homes are too beautifully kept and they really are lovely girls, several had their wedding dresses on for the occasion.
The syces quarters are quite horrifying.

I began to work at the Allied Forces Canteen which gets continuous mention in my diaries. But, encouraged by my parents, I also started to work at a makeshift tented clinic and dispensary and continued to visit schools and hospitals with my mother. The Clinic had been set up in Delhi to treat poor people and the villagers who either could not afford proper medical treatment or would not be persuaded to go near a proper hospital.

We treated every kind of case from smallpox and TB – which of course, one could really only diagnose and then send on to hospital – to prickly heat, boils, and the usual eye, nose and throat troubles and cuts and bruises. There were always crowds of patients and although we really knew nothing of nursing it was extraordinary how much, and how quickly, one could pick things up in necessity. There were often some very gruesome sights but when one was actually treating someone it no longer seemed as horrible as one had imagined.

Saturday 26th April
I went on to the Allied Forces Canteen where I am working two evenings

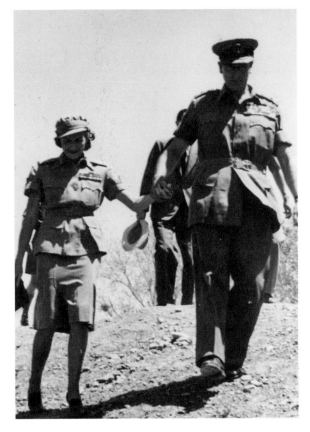

28th April: Going to confront 100,000 militant
Pathans advancing on Government House at Peshawar.

a week from five to seven. I do the milk shakes (eight flavours and very
complicated!).

Sunday 27th April
I went to see Lady Shone about working in the clinic and dispensary
she and Lady Smith and Mrs Thorat run to give free treatment to the
Indians, both at the clinic and touring around the villages.
 Started packing for the short tour we are going on to the NWFP and
the Punjab, as a result of the recent disturbances.
We gave a quiet garden party for the students from the Lady Irwin

College, the College of Nursing, the Lady Reading Health School and the Lady Hardinge Medical College. There were about six hundred girls and staff.

Riots in the North West Frontier Province and the Punjab

The trip to Peshawar was typical of my parents' imperative need to organise and see for themselves, especially for my mother. For my father this was to be only one of two chances he would have to assess this volatile situation with his own eyes before the transfer of power. For my mother this was the first of endless trips.

Monday 28th April
We left in the York and flew to Peshawar, arriving at Government House just before lunch. Mummy and Daddy went immediately on arrival to see a crowd of Leaguers who had assembled from all over the Province to see them, and numbered between sixty and a hundred thousand. Today Daddy received about 179 telegrams, 760 letters and 2,340 postcards!

The riots had been horrifically intense and my parents thought they must go to Peshawar, and of course I went too. But I wasn't allowed to meet the crowd of angry Pathans that had accumulated once they had wind of their impending visit. I was made to sit in Government House. The Governor and indeed everyone was acutely aware of the fact that my parents could be killed. Alan Campbell-Johnson describes the scene: 'Lady Mountbatten insisted on going with [her husband]. The crowd confronting us was certainly formidable. We climbed up the railway embankment... and looked down upon a vast concourse. There was much gesticulation... and a steady chant of 'Pakistan Zindabad.'

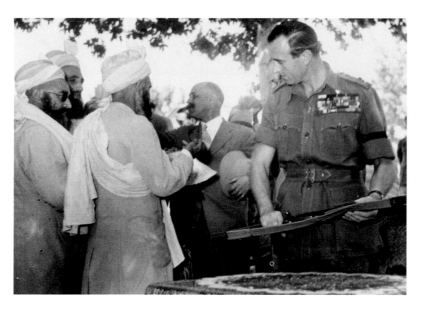

29th April: Afridi Tribes' last Viceregal Jirga, in the Khyber Pass.

My father, unabashed and fearless, strode ahead.

What these tribesmen saw was this small white woman holding her tall husband's hand, luckily wearing jungle green, the Pathans' holy colour. It was a terribly dramatic moment. There was no time for fear. My mother always said, 'There's no time for that darling!', and 'that' covered fear, pain and even protection at some junctures. And at times she was experiencing incredible personal suffering. She had had a major operation only a few weeks before we left for India and she suffered badly from 'neuralgia' (exacerbated by plane flights), which I now realise must have been migraines. But she never complained at all – her diary records all of her missions with a few added comments like 'feeling like death' but it didn't stop her.

Indeed she did work herself to death ten years later. She had been told that if she kept up the hard work she would be dead within three months, and she died of heart failure in Borneo. She had forbidden her doctor to warn the family.

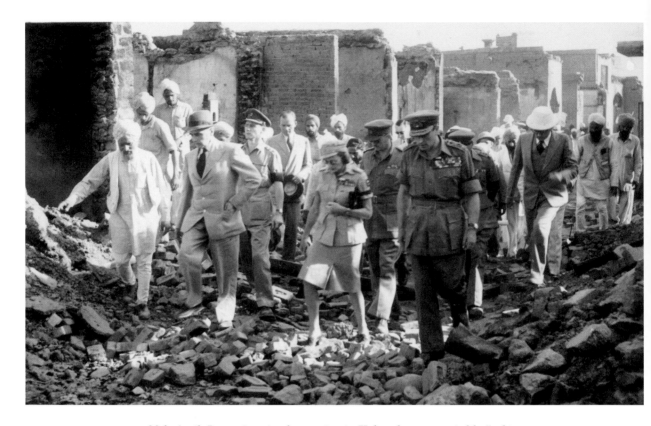

29th April: Inspecting riot devastation in Kahutal accompanied by Jenkins, the Governor of the Punjab.

I wrote to my friend Mary about this trip: 'We had five days in the North West Frontier and the Punjab touring round the refugee camps and burnt-out villages, but we were able to go up the Khyber Pass that leads into Afghanistan. The tribesmen of the Afridi and the other tribes up there really are remarkable looking people but rather alarming in habits. Complete tribal law prevails in the territory and comes under no Government jurisdiction.' At the local jirga [an assembly of village elders] my father said that he was asked far more difficult questions than at any press conference. The Alfidis were so astute and really put him on the spot.

Tuesday 29th April

We drove up the Khyber Pass to within view of the frontier of Afghanistan. It really was thrilling and not at all disappointing, but complete with men perched on crags on the skyline with revolvers and rifles slung all over them and wearing pyjamad uniforms. Then there was a Jirga of three hundred chiefs of the Afridis at Landi Kotal. After lunch we flew to Rawalpindi in the Punjab. We went to see Kahutal, one of the typical small towns which have now been completely burned down and destroyed by the Muslims, and the surviving Sikhs and Hindus have now fled. The tales they tell compare with the worst atrocities of the War.

'Until I went to Kahutal I had not appreciated the magnitude of the horrors that are going on.'
Louis Mountbatten, April 1947

Wednesday 30th April

Mummy and I left at six-thirty this morning to visit the refugee camp at Wah where over eight thousand Sikhs have now taken refuge, the remaining survivors of the Hindu population of the sacked villages. They have been through undeniably ghastly experiences. They have nothing to do all day but bemoan their fate. Our visit provoked mass weeping and wailing, with people kissing Mummy's feet and showing all their scars, or their shaven heads, which of course to a Sikh means the breaking of one of the sacred five K's through the weakness of his spirit [a terrible dishonour for a Sikh]. *All sides exaggerate, it is almost impossible to judge clearly.*

I returned to Delhi with Daddy.

Mummy stays on two more days to visit Lahore, Tonk and Amritsar.

A treat for Mizzen. The kitmagar *does not approve.*

Brief Respite:
May 1947

By the beginning of May we had been in New Delhi for a little over a month and every minute of the day had been filled – with assessments of the situation; conferences with Governors and Indian leaders; journeying to the riot grounds of the North West; accompanying my parents on endless tours of schools, hospitals and exhibitions; not to mention the normal 'Viceregal workload' of entertaining both international and domestic visitors who had nothing to do with the machinations of the political moment. I was also working at the canteen and the dispensary. My father had achieved in six weeks what had not been achieved in previous Viceregal tenures – a plan which offered the British an exit from India, and he had broken the deadlock between the major Indian political leaders. Pug Ismay was dispatched to London with the plan and we realised that we were all very tired.

Thursday 1st May
There was one of the usual lunch parties of about twenty but as Mummy
was away I had to act as hostess which was rather alarming.

Friday 2nd May
We saw the Governor of Bengal, who has been staying here to see Daddy
off. He is extremely ill with Bengal rot [and hence was not able to
attend the Governor's Conference the previous month].
I went to meet Mummy at the airport as she had come back early having
been unable to land at Multaan owing to bad visibility. She had been very
ill on the trip with bad neuralgia and general upset, and as Daddy also is
only just recovering from a bad go of Delhi belly it has been decided to
spend next week in Simla which should be rather fun. However, as with
almost everything the move is causing terrible headaches in organisation.

The truth was that my parents were exhausted. After so much
work my father had dispatched Ismay to London to see the
Cabinet with the proposed Mountbatten Plan for the transfer of
power. He had been working to 1am (later in crises) and reading
until 2 or 3am. We would then ride at 6.30am each morning before
it got too hot – as this was one of the only chances to spend family
time together and it also gave my father a chance to let off some
steam. But this hard scheduling was beginning to take its toll. My
father wrote in a letter dated 2nd May, to my sister Patricia: 'After
averaging 17 hours a day for 6 weeks I'm just about worn out and
must recuperate before meetings have to start on Pug's return.' It
was also getting unbelievably hot.

We wanted to go to Viceregal Lodge in Simla in the Himalayas
for just a few days. My father said to Colonel Douglas Currie
(the military secretary who was responsible for the movements of
the household), 'I've decided that Her Ex and Pammy and I are
going to go up to Viceregal Lodge and we'll only have two guests.
That'll be Pandit Nehru and Krishna Menon I think.' And Douglas

said 'I'm awfully sorry but it's out of the question. It would take me at least a month of organising for you to go up there.' My father said 'Well Douglas look, we're not going to give any garden parties. We're not going to give any formal dinners. We need a skeleton staff. Really it is just the five of us.' So Douglas said, 'Well even so your Excellency, I mean, if you knew the amount of work that goes into it.' My father said, 'Oh well Douglas, very well, don't worry. Book us into a hotel.' But we did go within a week. And when we arrived, I think my father asked what 'the skeleton staff' we brought with us amounted to and I've never forgotten the answer: it was 180.

Daddy invited Nehru and Krishna Menon to come and stay with us – as relaxed guests for walking expeditions.

Saturday 3rd May
…there was a big lunch party… then on to the Canteen.

Sunday 4th May
Daddy was not feeling too well so Mummy and Peter [Murphy] *and I had lunch alone at the pool.*

Peter was one of my father's oldest friends, they met while at Cambridge university. He was an excellent pianist, a marvellous raconteur and he had a brilliant brain.

Monday 5th May
I went to the Clinic for the first time. One really does see the most gruesome cases but when one is really face to face with them they never seem as horrible as one would have imagined… They are all so pathetically grateful. They treat cases that really no one who is not completely qualified ought to touch, but one is willing to take the risk when one knows that there is almost no hope of getting any other help. I saw my first case of smallpox on a baby who was brought in.

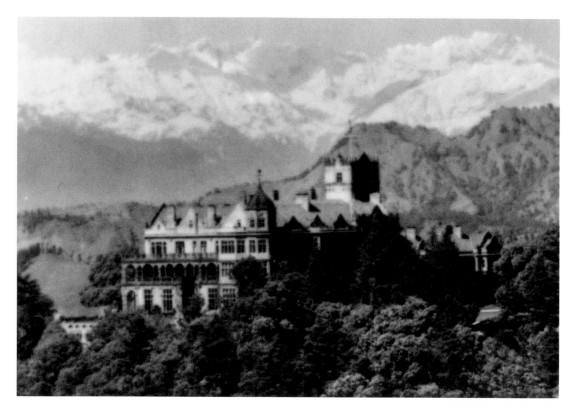

Viceregal Lodge, Simla, in the foothills of the Himalayas.

Tuesday 6th May
After lunch we all left for Simla, flying to Ambala (a horrible bumpy
trip) and then four hours up the mountains to Simla which is about
7,000 feet up.
Viceregal Lodge is a sort of Scottish baronial manor or castle spoilt by
thousands of little additions like statues and stone doves, but really quite
comfortable and well done-up with some lovely state rooms.

My mother wrote in her diary, 'House hideous. Bogus English
Baronial. Hollywood's idea of Vice Regal Lodge.' I had no idea
what it would look like. It was very large, albeit dwarfed by
Viceroy's House in Delhi. The décor was really rich. The rooms

weren't as large and as lavish as those at Viceroy's House.
Of course it was not cosy. But it was beautiful and had lovely
lawns. And you could play croquet and the strange things that
we never actually found we had time to do. We saw much more
of the British colony than one would have done in Delhi because
lots of them had retired up there, or they were the wives and
families who had escaped the heat.

But it was lovely to be there. You drove up through the
mountains. Half-way up, the air begins to get fresh, and by
the time you're right up at 7,000 feet, it's marvellously cool.
And life is transformed.

Another thing my mother very much disapproved of was, of
course, the Vice Regal rickshaws. They had uniformed runners,
and my mother could not bear the thought of riding in a vehicle
that was pulled by human beings. She was mortified. I think we
had one ride with her before she said she was never getting into
'that thing again'. Of course this came as a great disappointment
to the rickshaw coolies!

Wednesday 7th May
The air here is wonderful and one really does feel so energetic and well.
The scenery is quite lovely… We went for a walk through the woods. It
is alright going down but one forgets that one has got to come up again
and the paths are really terribly steep.
We all got terribly sunburned since although it is quite cold compared
with Delhi the mountain sun is very strong.

Then Panditji arrived to stay – I didn't know him well at that
stage. He had been invited as a friend but after a couple of days
my father began soul-searching and decided to show Nehru the
Mountbatten Plan to get his feedback. Nehru was incandescent
and kept Krishna Menon up until dawn the night that he arrived,
dictating the 'bombshell' letter dated the 11th May to my father,

which rejected many points of the plan which he saw as the 'Balkanisation' of his country. My father rethought and with the incredible and brilliant V.P. Menon, redrafted the whole plan and resubmitted it to London – much to the India Office and Attlee's confusion and perturbation.

Thursday 8th May
Pandit Nehru arrived to stay for a few days. We had lunch in the garden alone with Mr Nehru… Evening alone with Pandit Nehru.

Friday 9th May
We walked and talked in the garden with Panditji. Later on we joined up with Mummy and Daddy and party and had tea at Mashobra. The house there really is adorable and the obvious place to stay if one was up for a holiday. However it certainly is 'The Retreat' and can only be reached on foot. The famous orchards are most impressive.

Saturday 10th May
Krishna Menon arrived to stay.

Sunday 11th May
Yesterday evening Panditji gave us a demonstration of standing on his head, a performance he goes through for about ten minutes every morning and during which the major problems of India are solved! Actually he really is marvellously fit and had the three of us down on the floor doing the most extraordinary yogi exercises.
I had a long talk with Krishna Menon, about the most cynical person I've met so far but very interesting. They are all very frank in the way of never agreeing casually for the mistaken sake of manners but catch one up at once, something which takes some getting used to. [With hindsight, this is perhaps not surprising if he had been up all night prevously with Panditji!] *Panditji left.*

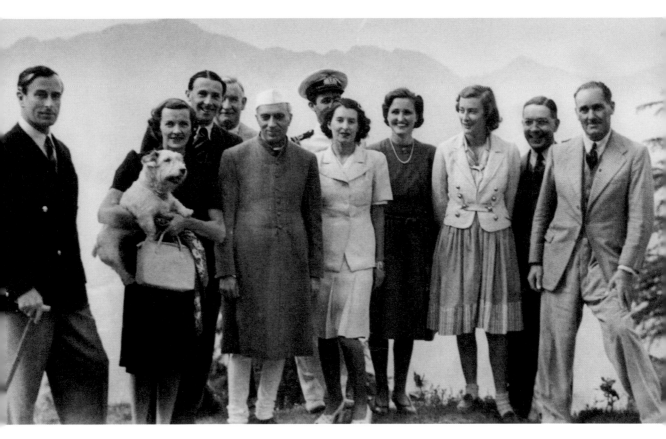

On the road to "The Retreat" the Viceregal Villa, Mashobra
D.E., Alan Campbell-Johnson, Reader, Nehru, Sayid Ahsan, Fay C-J,
Pammy, Eric Britter (The Times), Douglas Currie

Monday 12th May
Krishna Menon left.

Tuesday 13th May
We returned in the Viceregal rickshaws. The pace and distance they
run is fantastic, but it was really even more awful and truly degrading
(especially for the passenger) than I had even imagined.

With my parents and Mizzen on the Terrace.

Back to Delhi

Wednesday 14th May
*We came back to Delhi, where of course, one now feels the heat far worse
having spent some time in the hills. The heat in the shade is now about
113° and in the sun anything up 150°. This is the first time I have ever
really been in a temperature over 100°, but I think that probably by then
one is already so hot that however much it might rise one could not really
feel much hotter! It is at night that it is unpleasant, though, very difficult
to sleep in.*
*I went as usual in the evening to the Canteen where we seem to drink
more ourselves than we serve out!*

Thursday 15th May
I went to the Clinic. Its hours get steadily earlier and earlier as the heat

*increases, we now start at 8:00. It is the same with riding which now
generally starts at 6:15. It is extraordinary what one can pick up in
necessity and how quickly, as one just doesn't have time to stop and really
think of what one is doing as so many patients come now.*

*Mummy spent the day touring Multhan as a result of her failure to get
there last time.*

*It has now been decided that Daddy is returning to London for two weeks
for talks.* [about the subsequent and last-minute changes to the
Mountbatten plan] *Mummy is going too. They are to leave at the end
of the week.*

Hindustani Lessons and the Caravan of India

I started my Hindustani lessons with the fresh optimism of a
keen eighteen-year-old, it is only in later diary entries that my
frustration begins to show. It was also at this time that I first
became involved with the Caravan of India.

Friday 16th May

*Yesterday evening I had my first lesson in Hindustani. It is fun
learning and really essential to be able to speak it, as otherwise one is
terribly out of contact, but as it takes about a year to learn I might just
about be able to speak by the time we leave for home!*

*A man came to see me about a fun fair and bazaar I have been asked
to open. It is for a society called the Caravan of India, a branch of an
international American-founded, non-religious, non-political youth
organisation concerned with welfare work and international pen friend-
ships. The thought of making my first speech has ruined the whole week.
Mr Jinnah, Fatima and the Liaquats all came to dinner.*

Saturday 17th May

I went with Mummy to see all the quarters on the Estate, both the clerks'

Pammy opening Fun Fair of Caravan of India Club 18th May - Y.M.C.A.

houses which are quite nice, and the servants' quarters in the compounds which are terrible. It was the first time a Vicereine had been to see them, and about time too, although there is so little one can do in the short time left and so much needs doing. When one thinks that they were built only twenty years ago it is terrifying that they are so appalling. Although of course they are far better than the average quarters.

Sunday 18th May
I went to see Mummy and Daddy off. Sir John Colville, the Acting Viceroy, arrived yesterday with Lady Colville.
The house really is just like an hotel since except for occasional meals and parties or sometimes swimming or riding, one never meets each other at all.
I opened the famous bazaar in an absolute cold sweat and forgot large chunks of the speech which I had written and learnt, but luckily no one realised and the actual fair was terrific fun.

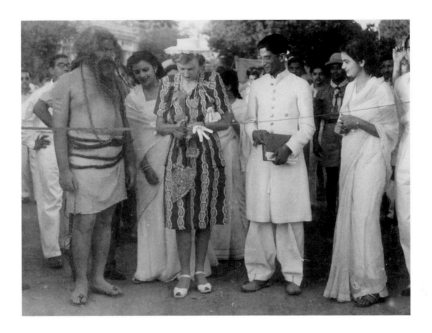

Cutting the tape to open the fun fair.

My first speech opening the fun fair of the Caravan of India Club was horrifying. I wrote it myself and said something as deep as 'I pronounce you open' or some such thing. When I came back to England, I found of course that the British arm of this international organisation all descended on me and I got out of it because it wasn't really the same thing at home. But in India, it was really the only youth organisation. Dear Ghulam Naqshband was always approaching me to do things, he was to become the bane of my life.

Tuesday 20th May
I had another Hindustani lesson and after a quiet lunch with their Exes, spent the afternoon reading and writing. It really is terribly hot at night now and so I have taken to sleeping in Mummy's room as it is properly air-conditioned. On her return I will have a camp bed in her sitting room as that is also air-conditioned. It is at night that the heat really bothers.

Thursday 22nd May

I went to the Clinic. Picking up the required phrases of Hindustani is quite easy but unfortunately they always seem to produce long and voluble answers which is most awkward!

I gather from the papers that Mummy and Daddy are getting along alright and everything seems to be going quite smoothly which is a relief.

[We got both the Indian national press and the overseas editions of the British press.]

Tuesday 27th May

I had one of the 'three times a week' Hindustani lessons. The teacher gets terribly enthusiastic and stays for hours and hours. It is quite fun and I badly want to learn but it gets more and more hopeless and muddling at the moment and I feel I shall soon drive both poor Mr Lal and myself to drink! I went with the Colvilles to a party given by Panditji and the External Affairs.

Wednesday 28th May

Panditji has sent me his Glimpses of World History *and the book of letters he wrote for Indira, together with a very sweet note. It was extremely kind of him to trouble as they are almost unobtainable now and so very exciting having them.*

Thursday 29th May

I went to the Clinic where everything was as busy and hectic as usual.

Friday 30th May

Of course, as with all Mountbatten departures or arrivals, this one upset every made plan and threw everyone into complete turmoil. First it was to be today, then tomorrow, now today only at 9:30am instead of 6:00. But that soon changed to 10:30 as the pilot went sick, then he got better and it was back at 8:00. Then threatened sandstorms stalled plans for landing at Ambala or Agra. They finally turned up at Palam at 10:20

My parents in a relaxed moment before going riding.

but having sent signals to put the Burma Star Party of 2,000 ahead by one day, and as all the invitations were already out chaos was renewed. It was great fun hearing all their news and about Patricia and Junior who sound flourishing.

Saturday 31st May
I went to the Canteen, which is usual on a Saturday.
We went to a reception given by the Chinese Ambassador, the first official party to be given by an Embassy in India.
Went on to a farewell cocktail party given by the Scots Fusiliers, who of course, have now just received orders to stay on!

*3rd June: My father broadcasting acceptance of the Plan over
All India Radio.*

The Mountbatten Plan: June 1947

June was characterised by a galvanisation of effort on the part of the Interim Government after the announcement of the Mountbatten Plan on 4th June and the date for the Transfer of Power on 15th August. But whereas at first it was expected that all would be amicable over partition, relations gradually worsened between Congress and the Muslim League throughout the month, and indeed in the months leading up to partition. My father settled down to a regime of organisation and speed, while my mother threw herself into making sure that the Indian medical and social welfare organisations would be ready for the exit of the British.

The month began with my father's return from London where they had approved all the amendments to the plan and both Attlee's Cabinet and Winston's Opposition had agreed to push legislation through as soon as possible. This allowed my father to return to India victorious and able to press ahead urgently with the moves that would lead to Dominion Status for both India and Pakistan. The first thing that was needed was to meet and get the Indian leaders' agreement (of course he already had that from Nehru), and secondly it needed announcing to the country and the wider world.

Sunday 1st June
Daddy came home [from London] *with the news that at last all seems settled.*
Philip and Lilibet [Princess Elizabeth] *soon will not be able to deny the rumours about them or ignore the 'Daily Mirror' polls!*

Monday 2nd June
The talks with the Indian leaders went on all morning so that one was continually bumping into them round corners and there were crowds of pressmen and photographers outside. However, they soon marched out in protest as they could learn nothing. Everyone is going round with rather set and glazed expressions as all the usual last minute dramas occur and there have been several instances when the entire plan was nearly wrecked by various people.

On 3rd June my father called a meeting with the Indian leaders to discuss the ways that two Dominions within the Commonwealth could be accommodated. He asked for their agreement by midnight. Only Jinnah nearly stymied the plan, saying that he would need to get the agreement of the Muslim League. My father persuaded Jinnah that if he couldn't give his verbal agreement at the meeting the next day, my father would at least get a nod of the head from him to signal that he would not rock the plan.

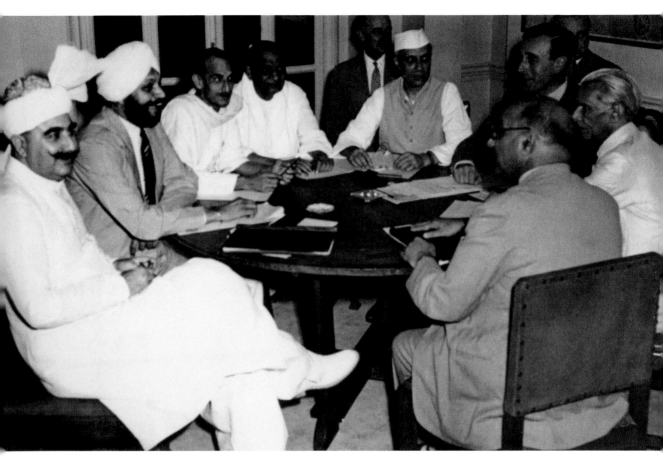

3rd June: The seven leaders accept the Transfer of Power Plan in the Viceroy's study. Clockwise: Mishtar, Baldev Singh, Kripalani, Patel, Nehru, my father, Jinnah and Liaquat.

Tuesday 3rd June
This morning part of the plan, which is at the moment dead secret and only known to the actual leaders, appeared word for word in the newspapers. Leakages seem almost immediate and completely uncontrollable. In the evening the announcement was broadcast simultaneously in London and Delhi. First Daddy spoke, an explanation of the course of events and an appeal for co-operation, then the announcement was read

*of the plan for Dominion Status by August for two self-governing
authorities of Pakistan and Hindustan, the possible partition of the
Punjab and Bengal and the reason for the failure to make a unified India
possible owing to complete disagreement. Finally Nehru, Jinnah and
Baldev Singh (for the Sikhs) and then an entire repetition in Hindustani.*

After getting the leaders' agreement (and Jinnah's nod)
on the 4th June, there was a big press conference at which my
father spoke eloquently without notes. My father's attitude by
the 3rd/4th June was that Partition was an absurd idea but
inevitable as the Indians wanted independence and couldn't
agree. But, he believed firmly, they must be the ones to make
it work.

The 4th June happened to fall on Gandhiji's day of silence.
Although his approval of the plan was not necessary to put it into
effect, my father knew that if Gandhi preached against it then
there could be appalling civil unrest. Luckily his subsequent
interview with Gandhi went well and he sadly accepted the
inevitability of Partition.

Wednesday 4th June
*Daddy gave an enormous press conference to over two hundred, the first
to be given by a Viceroy. It really was a tremendous success, although at
first they were all rather suspicious and puzzled by the obviously friendly
attitude of the proceedings.*

'If both of us – Hindu and Muslim – cannot
agree on anything else [aside from partition]
then the Viceroy is left with no choice.'
Gandhi prayer meeting 4th June 1947

My father wrote to my sister a few days later on 11th June that the
2nd/3rd June had been the worst twenty-four hours of his life.

Thursday 5th June
I went to the Clinic and spent three and a half hectic hours trying to deal
with an unending stream of patients in the most appalling heat, although
of course one feels it far less if one really is too busy to have time to think
about it. One doctor is away and the other two are sick so it was all
rather desperate. I managed to get hold of one of Andy Taylor's
[Surgeon to the Viceroy] *assistants to cope but he won't be able to*
come for long as they are very busy at the Viceregal Clinic too.

Friday 6th June
The Hindustani teacher came again. Although I have been assured the
contrary, it certainly seems just as complicated as most other languages,
the only thing being that the majority of the people don't speak it in any
way correctly themselves.

Saturday 7th June
Mummy and I went to look at one of the basement rooms which might
be suitable for the recreation hall we are trying to start for all the domestic
staff. I went to the Canteen as usual.

Tuesday 10th June
I went with Mummy to a small blind school just outside Tughlukkhabad.
They had nice light buildings and the pupils, as with most blind people
with their sensitive fingers, were doing the most beautiful spinning
and weaving.
I had an Urdu lesson!

Wednesday 11th June
Mr Naqshbahd came to discuss the Caravan of India and youth activities
in general with me.

Thursday 12th June
I spent the morning at the Clinic.
There was a big dinner party to celebrate the King's birthday and at

which we all got extremely hot and very bored.
We would have chosen the hottest summer that they have had out here
for over seventy-five years in which to come out!

Meanwhile there was a group of people who were not involved
in the discussions about the transfer of power – namely the
Princes, many of whom were friends that my father had been
introduced to in 1921 on his trip as ADC to the Prince of Wales.
My father's intention was that the Princes would either accede to
India or to Pakistan in return for a modicum of independence.
The wolves got to them in the end but he did at least secure them
a few years of protection and independence.

The plan was not meeting impassible resistance among the
ranks of Princes, with the exception of Kashmir (which had a
Hindu ruler but was mainly a Muslim state) and Hyderabad
(which had a Muslim ruler but was mainly Hindu). Nehru being
a Kashmiri was intent on travelling to Kashmir himself to see the
Maharaja, but my father realised the dangers inherent in that plan
and luckily we could take up a long-standing invitation to visit the
Prince ourselves. There was therefore a political expedient to our
trip to Kashmir – to convince the Maharaja to accept the plan –
and save Nehru humiliation.

In a letter to Mary I wrote : '[we spent] five wonderful days in
Kashmir. It is just as lovely as it is always described, hills and lakes
and gorgeous colouring. We saw the famous Shalimar Gardens
(and were reminded of the *Pale Hands I Loved* poem) and were
staying in Srinagar on the Dal Lake, but we were actually staying
in the Palace so everything was rather organised and we weren't
able to wander about. However, I saw my first black bear which
was exciting.'

Friday 13th June
We are going up to Simla for a few days before going on to Kashmir
which is lovely. We left at lunch time and consequently nearly died of

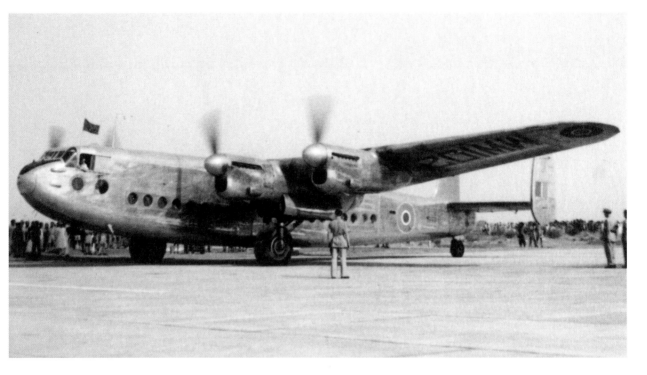

SACSEA/Viceregal 'York MW102'.

*heat at the airport. We are a very small party and are going to have only
a few people to meals which will be nice. Peter came up with us for a
holiday as he leaves for England quite soon now. We had a very nice
drive up in the open car.*

Saturday 14th June
I went into the town with Freddie [Captain Burnaby-Atkins, ADC]
and had drinks and ices with the Hoppers [some young American
friends]. *We had to take rickshaws back since, as usual, we were terribly
late for lunch and mine nearly ran down poor old Doctor Loh* [who later
became the First Chinese Ambassador to India]. *We got out and
rescued him and he was delighted to see us and he was quite by himself.*

Sunday 15th June
Mummy and I took Dr Loh to Mashobra. As a result of the expedition
he very sweetly sent me a book for what he called 'light summer reading'
but as it was conversations between Goethe and Ekermann I was not sure
that I agreed.

Monday 16th June
Daddy and Peter had to leave which was a great pity, but Mummy and
I are staying on for two more days and he is picking us up on the way
to Kashmir.

Tuesday 17th June
One of the new lady clerks, a charming girl called Miss Fellowes, suddenly
fell ill after she had only been here a few days. There was an extraordinary
story in which she appears to have been taken by the WVS [Women's
Voluntary Service] *to a solely Indian hospital where she subsequently*
could not be found. Finally traced by Susan Chance [Lord Ismay's
eldest daughter], *she had to be taken in an open truck, screaming and*
delirious through the streets of Old Delhi. Andy has been doing every-
thing possible ever since and she was recovering slightly when we heard
today that she had died. It really is too tragic, especially for the family
who were on their way out.

Wednesday 18th June
We left at five in the morning and motored down to Ambala where
Daddy and the York picked us up and flew on to Kashmir.
They have an extremely tricky airfield there and one has to fly through
the mountain passes, with some peaks 26,000 feet high, and then down
into the valley. However, we landed quite safely just before lunch and were
met by the Maharaja.

We drove with the Maharaja to Gulab Mahal and met the
Maharani Tera Devi and the Yuvraj, their son, the Crown Prince.
He went on to become very famous. He was known as Tiger and

19th June: My parents in Kashmir.

he later became a minister in the Indian government, and the Governor of Kashmir. 'Tiger of Kashmir' was a remarkable man. He married a beautiful Nepalese princess who was very useful and helpful too. But at this point he was only sixteen. We had lunch at Shalimar Gardens then went on to Nishart, which was even more lovely with wonderful fountains.

Thursday 19th June
Spent all day at the trout stream at Thricker.
The Maharani and the boy, Tiger, did not come. The latter is extremely nice, sixteen years old, but very ill with an unknown bone formation that makes him walk painfully. Daddy is trying to persuade them to send him to a London specialist.

Friday 20th June
The Maharani has been out of purda for some time but is very shy although very sweet. She does a great deal for the people and is popular. However, it is really just like living in the times of Henry VIII, the entire thing centres round the ruler, to all outward appearances, and the nervous tension of such an environment is quite awful. However, he has arranged everything for Mummy and Daddy painstakingly and down to the last detail and is extremely hospitable.
We went to Drapahama, the most lovely wild valley surrounded by forest-clad hills. I saw my first black bear which was thrilling. Daddy went vainly after it and made us all appallingly late for a big dinner.

We were kept busy throughout our stay and at no point did the Maharaja allow for a conversation with my father about 'accedence'. My parents were driven mad by this.

Saturday 22nd June
The palace is on the Dal lake so yesterday went out in HH's shikara. The rowers chant and shout out to each other and call out the various strokes which included the Lord Sahib, the Lady Sahib and the Miss

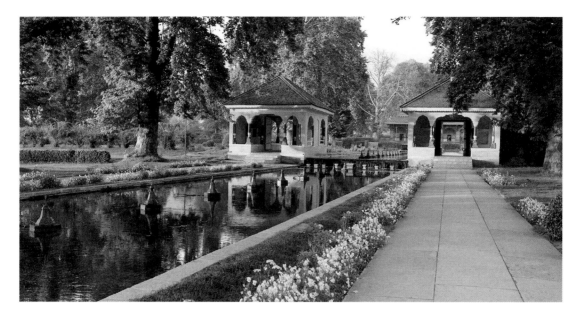

The Shalimar Gardens.

Sahib and which are caricatures of the people concerned.
We fished at Nambal beyond Thricker.
HH didn't come, said he's suffering from colic [which we gathered
was a diplomatic illness. The whole purpose of the visit had been
to persuade him to make up his mind to join either Pakistan or
Hindustan – his vacillation proved to be a precursor to the whole
Kashmir problem.]
After dinner the Maharani showed us her jewellery – astonishing.
Daddy upset both the dinner parties by unknowingly leaning against
the bell at table which rang solidly for ten minutes and ruined the
band's performance.

My father's frustration and disappointment at not getting the
Maharaja to make a decision has been vindicated over the years
by the ongoing territorial disputes in the region.

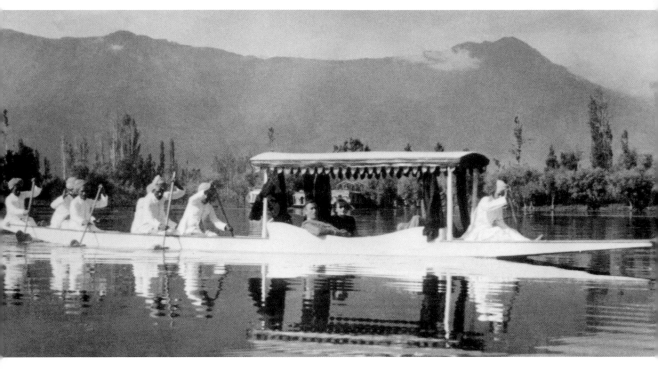

21st June: In the Maharajah's boat on the Lake at Srinagar.

Monday 23rd June
We flew back to Delhi, it took about three and a half hours, of which the
last 45 minutes terrible. Very sick and completely out on arrival. Together
with that, the various sudden changes of altitude and temperature we
have had, a slight touch of fever. I had to retire to bed feeling very ill.
Monty [Field-Marshal Montgomery of Alamein] *arrived just*
passing through on his way to Australia.

Tuesday 24th June
Peter Murphy left this morning for his journey home on an oiler, the story
of which we will doubtless never be allowed to forget.
Daddy had a special badge made for the Kitmagar behind Monty's chair
that instead of M of B said M of A. Monty was extremely pleased.

Wednesday 25th June
Staff investiture including knighthood for George Abell. We had all the staff to dinner, there were more than 40, almost half of them girls.
Saturday 28th June
Mr Kearney the Canadian High Commissioner and various millionaires came to lunch.

At the clinic the cases we were beginning to see were mostly wounds – many caused by Sikh kirpans, rather than disease.

Monday 30th June
I went to the Clinic in the morning. I now act as a kind of taxi service picking up and dropping a Mrs Annand and the wife of the ear, nose and throat specialist who have both started working there. We are getting quite a number of new helpers which is lucky as we now have to deal with up to 200 cases every morning: however the doctors keep on coming and going with continual changing about, it upsets everything and would be far more satisfactory if only we could get a permanent doctor.

The next problem to rear its head was that of splitting the army. At first it seemed that it could be accepted that Muslims and Hindus would continue to fight together but that was to prove too optimistic, as was my father's idea of meeting the rising tensions in the Provinces with force. They didn't know it, but they were entering a most incendiary and harrowing phase as the Provincial Assemblies of Bengal and the Punjab had voted for Partition. My father never doubted that Partition was a prescription for disaster. It was acceptable only because no alternative was available, but he and the Indian leaders had underestimated the hatred that would lead to the tit-for-tat killings and how quickly the Sikhs would be aroused to violence. Furthermore his staff were ill: Miéville had thrombosis; Ismay dysentery; Brockman was also invalided and my father described himself as looking 'haggard'.

Dear Sister,

So you are cele-
brating now the
silver jubilee of
your wedding
amid a shower
of congratula-
tions and good
wishes. Let me
add mine to them.
I hope that your
joint career here

will blossom
into citizenship
of the world.

I hope your
daughter is fully
restored.

Yours sincerely

M K Gandhi

Lady Mount-Batten
of Burma.

Gandhi's letter sent to my mother on 18th July 1947.

Rising Tensions:
July 1947

The month began badly as my father had expected to become the Governor-General of both India and Pakistan, but on the 1st July Jinnah put paid to those plans by announcing that he would become G-G of Pakistan. This left my father to decide whether to accept the offer to become G-G of India and therefore go against every non-partisan plan he had stood for in his tenure. Indeed his later acceptance of the governor-generalship of India did tarnish his impartial reputation and kindled persistent rumours that he was anti-Muslim League. A letter to Patricia dated 5th July signalled just how depressed he was with the situation: 'I have boobed', he wrote mournfully. It was the only time he admitted it.

My mother (and perhaps Stafford Cripps) was the only person
to beg my father to leave India after 15th August. Everyone else
advised him – or in the case of Congress begged him – to stay.
On 7th July Ismay and Campbell Johnson flew to London
to see the Cabinet and get their advice. It was debated in the
Cabinet and they agreed he should stay on – as did Churchill
and the King.

Back in India, the constant brawling between Congress and
the Muslim League meant that two Cabinets had to be set up.
My father was at the helm as Chairman, but he was very keen
not to be called to arbitrate – again he was certain that India
and Pakistan needed to learn to cope with their own problems.

Tuesday 1st July
I went off round the Bodyguard lines with Mummy and Daddy early
in the morning… Daddy gave them a short talk in Hindustani having
learnt it up in the bath aloud for days past! They really are remarkably
fine men but slightly shady characters. The other day one came up to
Paddy, the Commandant, with the request that he would 'grant him a
small favour' and say that he had returned from leave one day earlier
than in actual fact. He was hotly followed by the police demanding his
arrest for murder! However, it is quite possible that he was framed.

The learned speech was typical of my father who would want to
touch something in the hearts of the rank and file.

Wednesday 2nd July
Yesterday the American Ambassador came to present his credentials and
have lunch with us.
I had a Hindustani lesson and went to the Canteen.

Thursday 3rd July
I spent most of the morning at the Clinic.
Panditji came to lunch with Mrs Pandit. She has been appointed

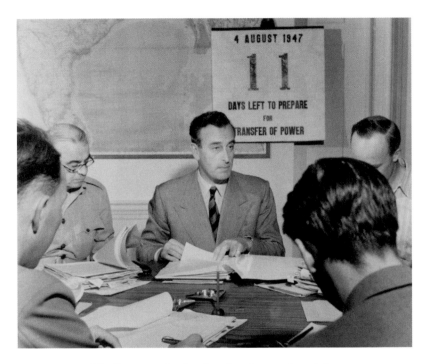

*The famous calendar showing the number of days
until the transfer of power.*

*Ambassador to Russia and will be leaving soon. She is taking Lekha with
her which should be fascinating for her as so much is discussed about
Russia and so little is really known.*

*Daddy has had a calendar distributed to most offices saying ' …days left
to transfer of power', so as to impress it upon the various government
departments, as it is horrifying how quickly time passes and 15th August
is not very far off now in comparison with what remains to be done.*

Saturday 5th July

*I went to the Canteen as usual leaving Mummy to go off and have tea
with Gandhiji at Banghi Colony!* [Certainly a first for a Vicereine.]

*Overleaf: The officers of the Bodyguard with my father, Colonel Currie,
the Military Secretary and myself as their Welfare Officer.*

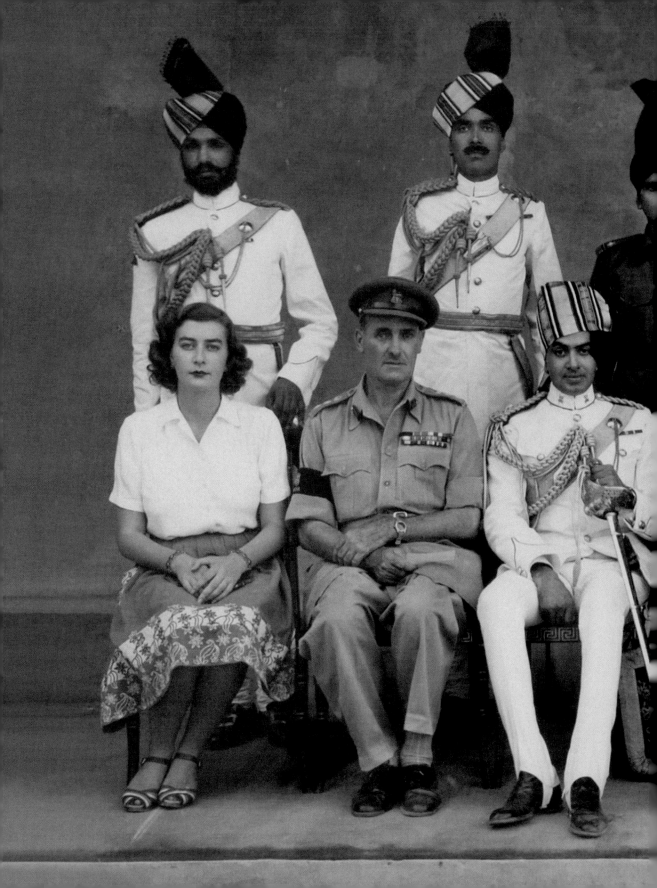

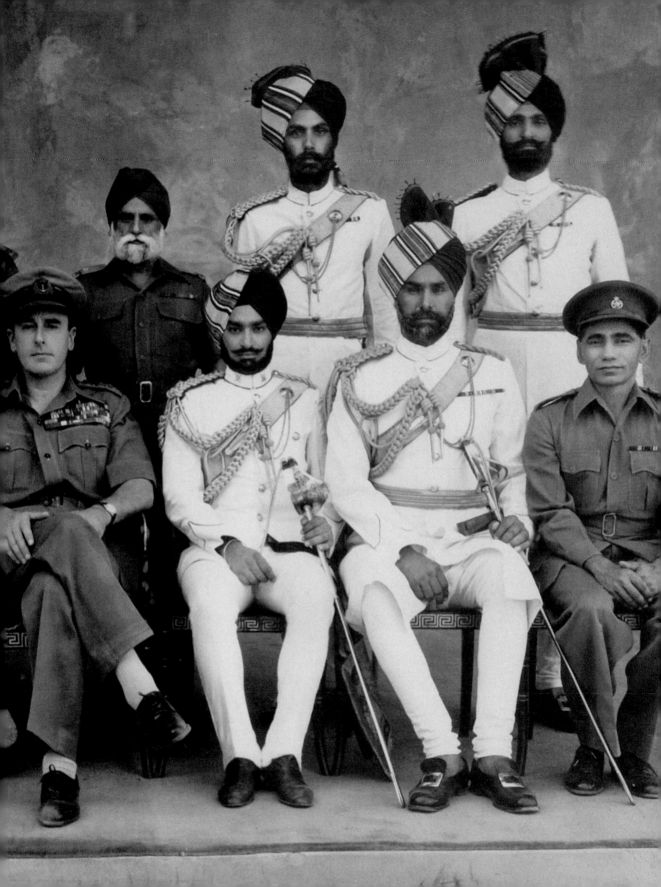

With tension rising, the Punjab Boundary force was put in place under Major-General Pete Rees (made mostly of non-partisan Ghurkas). At this time the Muslim League suggested strongly that it should be the UN that divided the Punjab and Bengal but Nehru would not agree. On the 8th July Sir Cyril Radcliffe arrived in India from London to prepare the boundaries between the two dominions. He was famed for his probity. He had never been to India before (something which would ensure his impartiality, it was reasoned). He did not stay with us but in another house on the Estate so that my father was seen to have no influence over any of his decisions.

Wednesday 9th July
The Staff have given Daddy and me a baby mongoose. It is quite adorable but smells to high heaven. It is only about six inches long and three weeks old but they are said to grow about two feet with another foot for the tail and become quite tame.
Krishna Menon has been appointed High Commissioner for the UK and so will be leaving at the end of the week. I went to the Canteen.

Gandhiji's Prayer Meeting

Thursday 10th July
The announcement of Philip and Lilibet's engagement has been made and has received a very enthusiastic and sweet welcome.
In the evening Krishna [Menon] took me to Gandhiji's prayer meeting. We called on him first in his little quarter in Banghi Colony, a very small but beautifully kept room. He wanted to know all about the 'happy event' which turned out to be the engagement. (He showed me his three wise monkeys in ivory. One of the very few possessions he still keeps).
The [prayer] meeting was fascinating.
A large crowd, as always, and a remarkable atmosphere. A verse from the Koran (it is a universal prayer meeting) and an Arabic hymn chanted,

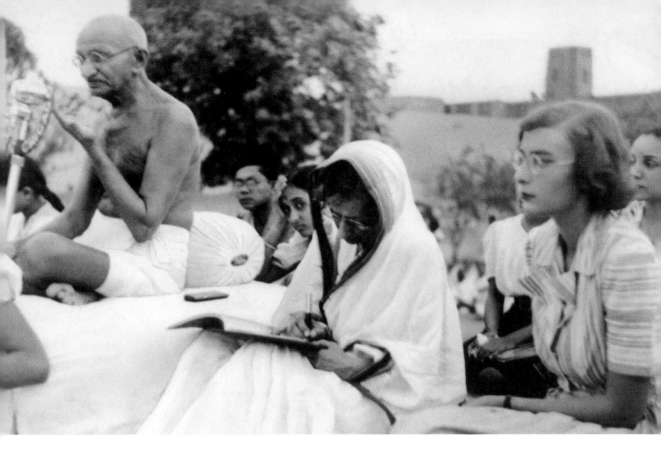

*Pammy attending Gandhi's Prayer Meeting
with Raj Kumari Amrit Kaur
10th July*

*two minutes silence and the usual forty minute discourse. The awe in
which he is held and the power of his personality are quite extraordinary.*

The whole meeting of course was in Hindi and I could not
understand a word, but you looked at the crowd and saw not one
person fidgeting. Everybody was absolutely silent in rapt attention.

My mother had been to tea with Gandhiji at Banghi Colony
before of course, but it was considered inappropriate for my parents
to actually attend one of the prayer meetings as it might have been
thought that they were supporting one of the Hindu leaders and
could have been criticised by the Muslim League. I, on the other
hand, was not an important enough figure for it to matter.

I went to the meeting with Krishna Menon (who had been with Gandhiji for a long time and of course had been a member of the London County Council). We drove in one of the Viceregal cars, picked up Krishna, then went to Banghi Colony where we walked across to see Gandhi's quarters. It was near the sweepers' colony, the poorest colony there was. Having met Gandhiji there, we walked out onto the platform with him. It cannot have been more than a hundred yards from his room. People were already sitting, keeping their places so as to be able to listen to him – if you got up and left your place of course you lost it at once. There were thousands of people there but it was very calm.

Gandhiji came to have a number of talks with my father. On one occasion he remarked that Viceroy's House, which he referred to as a palace, would have to be turned into a museum or college after we had gone. It was far too big for one man to live in. My father replied, 'Gandhiji, India will be the largest democracy in Asia. The eyes of the world will be upon her. The Heads of State will come to visit and you will need to entertain them and to impress them. The man who lives in this house will not be a private person, he will be representing India, and he should live accordingly.'

It was not long before Gandhiji returned with another anxiety. He told my father that he was worried that once they assumed power the ministers would become arrogant. He was planning a way to ensure that they remained humble. Gandhiji said that he kept a spinning wheel and spun every day. He felt that the ministers should devote one day a week to gardening and house-work. 'But Gandhiji,' my father replied, 'they will scarcely have time to complete the work on their portfolios. They will never have time for housework and hoovering.'

Saturday 12th July
We went riding on the Ridge. When we were almost home, Mummy and Daddy continued on ahead. Still rather unsafe in the side saddle, I pulled

18th July: My parents on their silver wedding anniversary.

the Ace up to go slower and he, both impatient and still unused to the saddle, started bucking. Unconsciously acting as I might have done astride, I slipped my foot out of the stirrup and eventually hit the ground. It is quite a fall as one goes right up and over the other side.
I was knocked out and taken home bruised and concussed.

Sunday 13th July
Everyone has been very sweet and sent countless messages, including an enquiry from Gandhiji after his 'naughty friend' as though I had wanted to fall off! And it was even reported in The Statesman *and the English papers which sounds as though I slipped off, very mortifying, they might at least have said 'thrown from horse'. My headache has almost gone.*

20th July: My parents inspecting riot devastation in Lahore in the Punjab.

Friday 18th July
Mummy and Daddy's silver wedding. Some lovely presents and countless
very touching messages… In the evening they gave a dinner party for
one hundred guests which was unique in that all the members of the
Cabinet came as well as Members of Congress, the Muslim League and
Minorities accompanied by their ladies and various ruling Princes of the
most diverse views.

My parents were extremely tired by this time and there were
many arguments. However, they were too accomplished at their
jobs to let it show publicly. American diplomat George Merrill
and the Governor of the United Provinces, Sir Francis Wylie

My mother and father with Sir Evan Jenkins.

decided one evening when they were watching my parents at a party for their anniversary, that 'in all history no revolution had perhaps been put through with so much grace.' It was a testament to their consummate skills of showmanship and their respect for each other.

Sunday 20th July
My parents flew to Lahore to see Sir Evan Jenkins and inspect the riot devastation there.

Overleaf: The letter to my father from Prime Minister Attlee.

10, Downing Street,
Whitehall.

17.7.47

My dear Dickie

I have read your last report with
very great interest. You are managing to
jump a lot of awkward hurdles.
Our debates on the Bill went very well
& the opposition played up well and helped
us to get it through. The only real opposition
came from Rankeillour and Selborne in the
Lords, but nobody took much notice.

I was glad that so many well deserved
tributes were paid to you by everybody
who spoke. I know too that it is well
recognized that Edwina has played a
great part in creating the new atmosphere
It was a great help having you here
during this critical fortnight.

I realise how heavy a time you will
have during the next four weeks
especially.

We are all very grateful to you for
carrying on for this next stage

I am very conscious that I put you in to bet on a very sticky wicket to pull the game out of the fire. Few people would have take it on and few, if any, could have pulled the game round as you have

Philip's engagement has been received with great enthusiasm by everyone. I hope you will be able to get some rest as I am sure you must need it. I hope to get away for most of August.

With all good wishes to you all

your own

C. M. Attlee

A letter arrived from Attlee dated 17th July: 'My dear Dickie. I have read your last report with very great interest. You are managing to jump a lot of awkward hurdles. Our debate on the Bill went very well, the opposition played up well and helped to get it through... I was glad that so many well deserved tributes were paid to you by everybody who spoke. I know too that it is well recognised that Edwina has played a great part in creating the new atmosphere. We are all very grateful to you for carrying on for this next stage. I am very conscious that I put you in to bat on a very sticky wicket to pull the game out of the fire. Few people would have taken it on and few, if any could have pulled the game round as you have...'

The Chamber of Princes

'The Princes are divided and uncertain, baffled by the pace of events.'
Alan Campbell-Johnson

At this time there were 565 separate states and provinces ruled over by the feudal Princes. Hindu Congress did not want their independence to remain after partition as it would Balkanise (segregate) India. My father, who was a close friend of many of the Princes and who, as a cousin of the King-Emperor, was well respected by them, realised that not only must they not impede the greater good by refusing to accept the new dominions, but that he could help to protect them if they acted while he still had the power of the Viceroy. He therefore decided to persuade them, or push them if necessary, to accede to Pakistan or India on reasonable terms which would ensure that they retained privileges and, albeit very limited, independence. But it was asking a lot of the powerful Princes to surrender that power voluntarily.

25th July: My father addressing the Chamber of Princes.

V.P. Menon, my father's star aide (who had helped him redraft the Mountbatten Plan in Simla after Nehru's 'bombshell') had helped to draft this solution for the princely states, allowing them to accede to either India or to Pakistan, both of which, as Dominions, would still have the King as Head of the Commonwealth.

The Chamber of Princes assembled on 25th July, headed by Baldev Singh, the leader of the Sikhs who was a very splendid looking man, very courageous and who spoke very well. The leaders included Bhopal (the Muslim ruler of a Hindu State), who agreed to accede. He was an old friend of my father, but the arguments over partition ruined their friendship. Also present were the Maharaja of Jodhpur (who theatrically brandished a revolver in a fountain pen at my father – both he and my father

were in the Magic Circle and the pen is now in their museum);
and the Nizam of Hyderabad (the Muslim leader of a mainly
Hindu state), India's largest state – the size of France – with
16 million people, who vacillated in his decision to accede until
the last moment in 1948.

My father appeared at the conference resplendent in full
uniform and decorations. During his speech, which was delivered
with great sincerity and passion, he spoke without notes and
was, in the words of V.P. Menon, the very 'apogee of persuasion'.
A lot of lobbying followed but after a big Princes' lunch on the
1st August he had persuaded most of them – with of course the
exception of Kashmir.

There was another dramatic moment when one of the Princes'
dewans (Chief Minister) who had been sent without a brief,
pleaded that he didn't know how to answer my father's request to
accede. My father thinking quickly, picked up a glass paperweight
in front of him and held it aloft saying, 'I will look into my
crystal…' There was a lengthy pause while no-one said anything.
'His Highness asks you to sign the instrument of accession,' my
father said with great portent. Of course this served to break a lot
of the tension that had pervaded the conference and brought some
welcome laughter to the proceedings, which were otherwise
extremely distressing for most who attended.

Friday 25th July
The Jinnahs came to dinner.

It was at this dinner party that George Abell came to the
conclusion, as he told Alan Campell-Johnson, that Jinnah's
'attitude to the Sikh situation was perilously unsound'. My
mother was also becoming frustrated by him; she vented her
feelings in her diary: 'He has already become meglo-maniac…
so God help Pakistan.'

The Maharaja of Gwalior's silver train set.

Saturday 26th July
Panditji, his daughter Indira and her husband and Mrs Pandit came
to dine.

While dining with the Maharaja of Gwalior we admired his
silver train, which circled the dining table delivering port, brandy,
cigars chocolates to the dinner guests. The controls were in front
of His Highness, and if a guest was out of favour they might find
that the train sped away before they could help themselves.

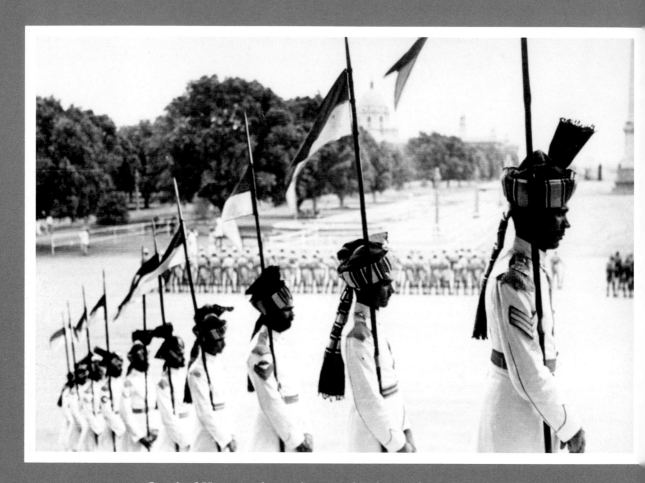

Guards of Honour and some dismounted Bodyguard beginning to form up
for Ceremonial departure.

The Transfer of Power:
August 1947

The date for the transfer of power came around all too quickly. We had only been in India for a little less than five months and the India that we had known for that short period was about to change for ever. Of course everyone was far too busy then to reflect upon the true significance of events as they unfolded. It was a time of excitement and raw nerves and my diary pages for those August days overflowed as I tried to capture all the momentous details.

My father's ADC, Sayed Ahsan, was a Muslim and therefore went to work for Jinnah. It was at this time, when he and the Muslim sentries and police started to leave, that I really began to understand what partition would mean for the communities.

Saturday 9th August
Immediately after breakfast there was a review of the garrison company, and the Viceregal and C-in-C sentries and police, who are all Muslims, and so are leaving for Pakistan and will have to be replaced.

Sunday 10th August
Played with the mongoose who is very tame now and quite intoxicating and always runs about in my rooms when I am there. It is developing into rather a menace, as it chews up everything.

Monday 11th August
It was a terrible day at the Clinic, very overcrowded and everyone hot and damp and extremely cross.
The Netherlands Ambassador came to present his credentials and there was a lunch party for them all afterwards.
Eric [Miéville] was there and seemed much more cheerful although still far from well.

Tuesday 12th August
I had a Hindustani lesson, but it is very difficult now that I have done all the actual grammar but still do not know enough words to be able to make conversation. We do the lessons without books, and as there is nothing else one is terribly tempted to lapse into English. As all the servants speak such good English it is therefore not a case of being able to learn through absol-ute necessity, and the more one practises the less time there is at the Clinic.

Wednesday 13th August
We all flew to Karachi for the preliminary transfer of power

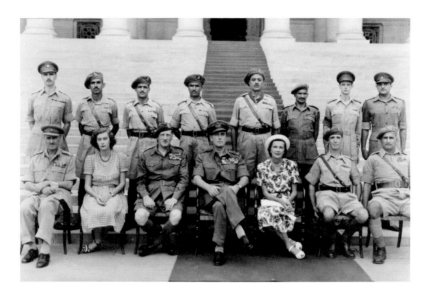

9th August: Group with Field Marshall Auchinleck and Officers of the Viceroy's Garrison Company after the farewell parade in Delhi.

ceremonies. It seemed so strange to be greeted at the airport by Sayed Ahsan [my father's former chief ADC] *The Jinnahs were in very good form and they certainly have the most lovely modern Government House. However, everything was of course rather chaotic and poor Sayed was obviously having to run the whole show. When we first arrived, the town, predominantly Hindu in itself, was flying mainly Congress flags but the Pakistan Star and Crescent were eventually substituted! There was a big dinner party and reception and it seemed so queer meeting the Scotts and Yakub and various other members of our staff whom we knew well but who of course have left us.*

Thursday 14th August
We went to the Ceremony at the Constituent Assembly and Mummy and Daddy drove back in state with the Jinnahs, in open cars. I drove with Begum Liquat and there were quite thick crowds and cries of 'Quaid-e-

Overleaf: A letter written to my father by his cousin, King George VI.

August 13th 1947

My dear Dickie,

Before you hand
over your powers as Viceroy
of India to the two new
Dominions, the Union of India
& Pakistan, I do want you
to know & to realise how
much I have admired the
way in which you have
tackled the enormous
task of divideing the
Hindus & Muslims into
two different Dominions

simply by the forces of tact & persuasion. I am sure that there is no one else who could have accomplished this feat in the short time at your disposal except yourself. I am so glad that nearly all the Indian States have decided (again with your help) to join either one or the other of the Dominions. They could never have stood alone in the World. Please accept my thanks & my congratulations.

Ever

Yours Bertie

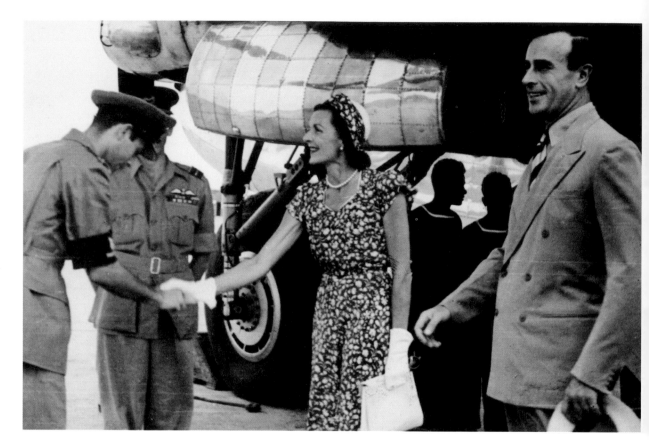

13th August: My parents arrive at Karachi and are received by Jinnah's new ADC Sayed Ahsan, until recently the Viceroy's Naval ADC.

Azam Zinderbad' and 'Mountbatten Zinderbad'. Immediately afterwards we flew back to Delhi in order to be in time for the 'Midnight Mysteries'! Tomorrow being in itself an inauspicious day we have to have part of the ceremonies at midnight. Therefore Panditji and Rajendra Prasad came after the meeting of the Assembly to ask Daddy to accept the governor-generalship.
We toasted the King-Emperor for the last time and drank the Viceroy out and the Governor-General in. By midday we said goodbye, Miss Jinnah embracing Mummy and Mr Jinnah still emotional, declaring his eternal gratitude and friendship.

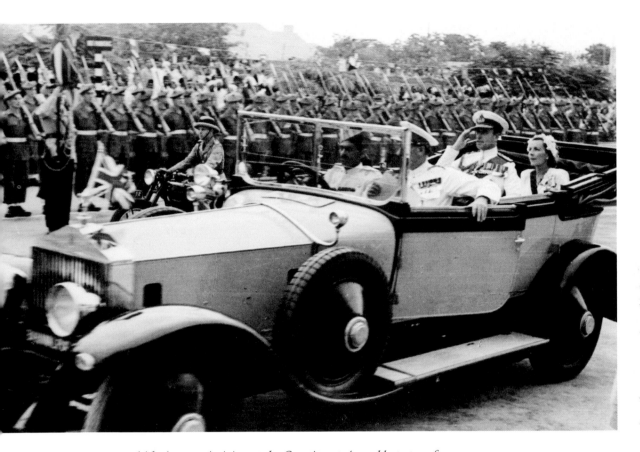

*14th August: Arriving at the Constituent Assembly to transfer power
to the new Dominion of Pakistan.*

The 14th August was the actual day of independence. Jinnah's
personality was cold and remote but it had a magnetic quality
and the sense of leadership was almost overpowering. He made
only the most superficial attempt to disguise himself as a
constitutional Governor-General and one of his first acts after
putting his name forward was to apply for the authority to hold
immediate dictatorial powers unknown to any constitutional
Governor-General representing the King. Here indeed was
Pakistan's King-Emperor, Archbishop of Canterbury, Speaker and
Prime Minister concentrated into one formidable *Quaid-e-Azam*.

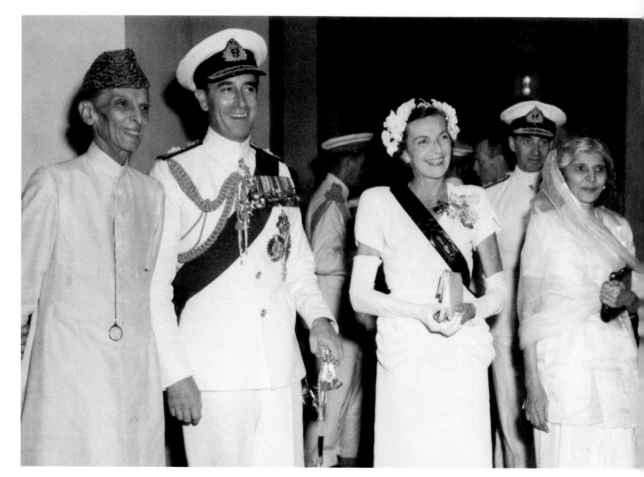

All four gay on safe arrival at Government House, Karachi, 14th August

(Jinnah had very effectively quashed my father's hopes of becoming Governor-General of Pakistan – in an attempt to retain a balanced position towards both countries – back in July.) The proceedings were over within an hour and then we drove away in state, arriving back at Government House.

Jinnah was an icy man, but on this occasion he showed emotion. He leant over to my father, put his hand on his knee and said

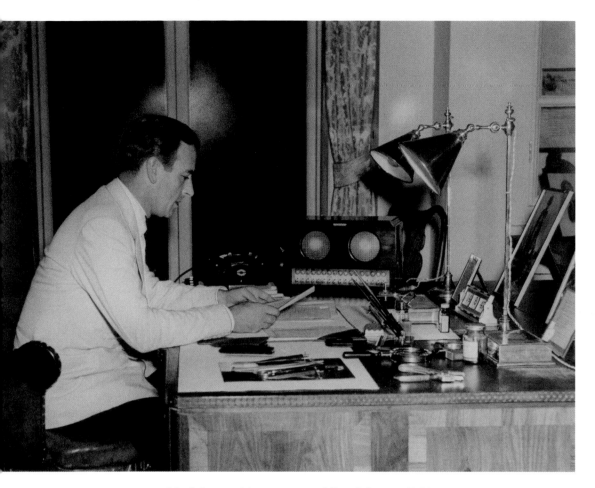

*My father receiving a purported list of the new Cabinet
(the paper turned out to be blank!).*

with evident feeling, 'Your Excellency, I'm so glad to get you
back safely.' There had supposedly been a bomb that was to be
thrown during the processional drive. My father thought, 'What
do you mean? I got you back safely.'

We then flew back to Delhi. Before the Constituent Assembly
met, my father was sitting at his desk waiting for Nehru and
Rajendra Prasad to come to invite him formally to be Governor-
General. There was an hour or two where nothing happened.

*Midnight 14th/15th August: Prime Minister Nehru and the President of
the Assembly, Rajendra Prasad, report taking over power.*

My father suddenly became aware that, as Viceroy of India,
he had had enormous power, but in about an hour's time, as
a constitutional Governor-General, he would have very little
indeed. It seemed a terrible waste to let this power slip away
without making some use of it. Then he remembered that his
dear friend the Nawab of Palampur had long entreated him to
make his wife, the Begum, a 'Highness'. The Colonial Office had
always refused because she was Australian and they said it was
inapplicable – even though she was enormously popular in the
state and continued to do wonderful work there. So my father
thought, 'Ah, with the last power remaining to me I shall draw
up an instrument and make the Begum of Palampur a Highness.'

And he did so with great satisfaction.

After the meeting of the Assembly, we toasted the King-Emperor for the last time and drank the Viceroy out and the Governor-General in. When they came with the invitation to my father, Nehru also presented him with an imposing envelope that he said contained the list of the names of the new government. After they left my father opened the envelope and found a blank piece of paper – in the rush of events someone had stuffed in the wrong piece of paper.

Friday 15th August
Independence Day. Swearing-in ceremony in the Durbar Hall. Daddy
sworn-in as the first Governor-General of India by the new Chief Justice,
Dr Kania, before himself swearing-in the members of the Cabinet.
Daddy has been created an Earl, so Mummy is a Countess and I have
the courtesy title 'Lady' before my Christian name. Lovely!

The entry in my diary for the 15th August runs to four pages (not surprisingly) and the last two are written in tiny hand on the blank pages at the end of the book as it was so important that I got everything down for this most important of days.

Mummy wore a long gold lamé dress and a little wreath of gold leaves on
her head. With the golden thrones and golden carpets and the red velvet
canopies over the thrones spot-lit it was very sumptuous. The trumpeters
in scarlet and gold had heralded a splendid entrance. At the end of the
ceremony the great bronze doors were thrown open and 'God Save the King'
was followed by the new Indian national anthem, 'Jana Gana Mana' –
and the new Indian flag, which Panditji had described to us, was flying.
Then Mummy and Daddy, escorted by the Bodyguard, drove in the state
carriage down to the Constituent Assembly. I was already sitting with the
staff but when the carriage arrived the Council House was entirely
surrounded by a quarter of a million frenzied people chanting 'Jai Hind'.
With the laughing, cheering crowd already engulfing the carriage, it

*looked as though it would be impossible for Mummy and Daddy to
make their entrance. Panditji and other government leaders had to be
summoned to help calm the crowd and to make a passage for them.
Daddy read out the King's message to the new Dominion of India. And
then he gave an address that resulted in prolonged cheers because, as one
Indian said, 'His gift for friendship has triumphed over everything.'
Then the President of the Assembly, Rajendra Prasad, read out
messages from other countries, and gave an address in which he said,
'Let us gratefully acknowledge that while our achievement is in no small
measure due to our own suffering and sacrifices, it is also the result of
world forces and events, and last though not least it is the consummation
and fulfilment of the historic tradition and democratic ideas of the
British race.' He followed with tributes to Mummy and Daddy.
After the ceremony they could not get out of the doors for some time as
the crowds were still so thick. They clapped and shouted themselves
hoarse with cries of 'Pandit Mountbatten ki jai,' 'Lady Mountbatten',
'Jai Hind' and all the popular cries for the leaders. Driving along, some
even recognised me and shouted 'Mountbatten Miss Sahib' or even 'Miss
Pamela' and when they did not know who one was they cheered one for
being 'Angrezi'.
In the afternoon we went to a fête for 5,000 children. It was terribly hot
and, of course, very, very noisy but the children and their young
parents were wildly enthusiastic. I enjoyed handing out sweets but did
not enjoy the sight of a fakir apparently biting the head off a snake.*

We had to rush back from Old Delhi in order to change for
the Flag Salutation Parade in Prince's Park. The programme
had been arranged weeks beforehand, grandstands had been built
and military parades organised, but no one had anticipated the
enthusiasm of the crowds. My parents were to drive in state and
I went ahead with Captain Ronnie Brockman – who had been
Personal Secretary to the Viceroy and would now be Private
Secretary to the Governor-General – his wife and Muriel Watson,
my mother's Personal Assistant, and Elizabeth Ward, my mother's

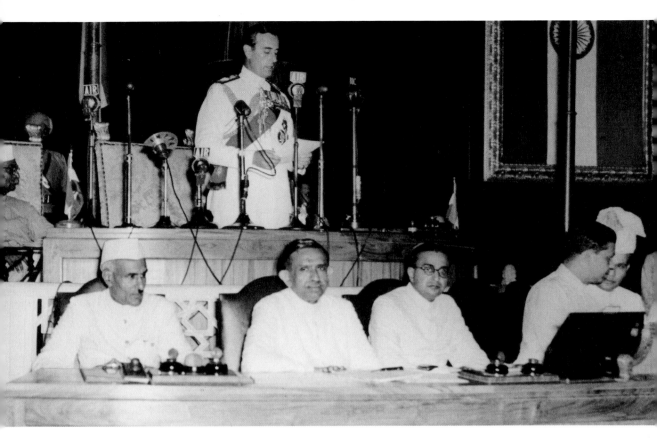

15th August: Ceremony of the transfer of power to the new Dominion of India in the Constituent Assembly Council Chamber.

Personal Secretary. The Parade, however, was non-existent. The grandstands were buried under a sea of people and the only sign of the parade was a row of bright pugarees (turbans) somewhere in the centre, the men still standing at attention because the crowd was so closely packed that there was not room for them to stand at ease. There was no ceremony at all, but it was the day of the people of India and far more impressive than any pageantry could have been. We fought our way on foot from the cars to what would have been the stands had they not been buried under five hundred thousand people. There was no room to put a foot

down. There was no possible space between people. In fact, it was raining babies! Lots of women had brought their babies with them and they were being crushed, so they threw them up in the air in despair and you just sort of caught a baby as it came down. And some people had come with bicycles. There was no question of putting the bicycles down: they were being passed round and round overhead.

Panditji came to rescue me and led me to the tiny platform that surrounded the flagstaff. He grabbed me by the hand, but I said 'I cannot come. Where do I put my feet? I cannot walk on people.' He said, 'Of course you can walk on people. Nobody will mind.' Of course, nobody minded him walking on them but I had high-heeled shoes which would hurt a lot. So he said, 'Well, take those shoes off, then nobody will mind.' And he walked over human bodies the whole way, and the extraordinary thing is that nobody did mind. So I took my high-heeled shoes off, and he and I literally walked over the laughing, cheering people seated on the ground. In this way we reached the platform where I joined tiny Maniben Patel, Vallabhbhai's daughter. Panditji made her and me stand with our backs against the flagstaff as he was afraid we might be knocked over in all the excitement. The state carriage finally inched its way into sight together with its own crowd and we and the whole platform were buried under a mass of shouting, pushing, sweating people, but incredibly good tempered and friendly.

The carriage could not get near, neither could the bodyguard escorting it. Daddy had to remain standing up in the carriage and salute the flag at a distance of twenty-five yards. Panditji had travelled back over people to try to make a passage for the carriage. Having failed, he then could not get back, so Daddy hauled him into the carriage where he sat on the hood. And they ended up having to drag four women, a child and a press photographer into the carriage as they were in danger of being crushed under its wheels. It finally left with most of the crowd running along beside it, Mummy and

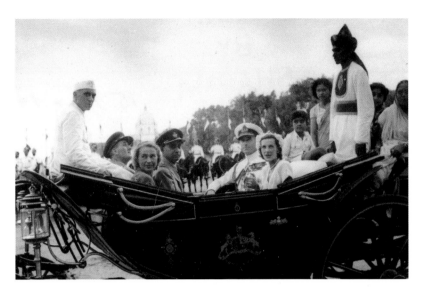

Returning from the Flag Raising Ceremony with Nehru and others we had saved from being crushed by an enthusiastic crowd.

Daddy standing up waving and people hanging onto the carriage cheering and shaking them by the hand and throwing flowers and flags into it. The final tally was the Prime Minister riding on the hood and ten refugees crammed inside with Mummy and Daddy.

When the bits of us that remained arrived back at what is now Government House I was bruised from top to bottom. But one never minded a bit. Everybody was so thrilled and excited that nothing could have mattered. We immediately went out to see the firework displays and illuminations. Afterwards there was a big Independence Day dinner party for over one hundred, followed by a reception for 2,500, each one of whom was presented to Mummy and Daddy. Quite tiring! All the state rooms and drawing rooms were open and the party overflowed into the Moghul Gardens which were flood-lit and festooned with fairy lights, and blissfully cool.

Overleaf: Leaving the Constituent Assembly on 15th August 1947.

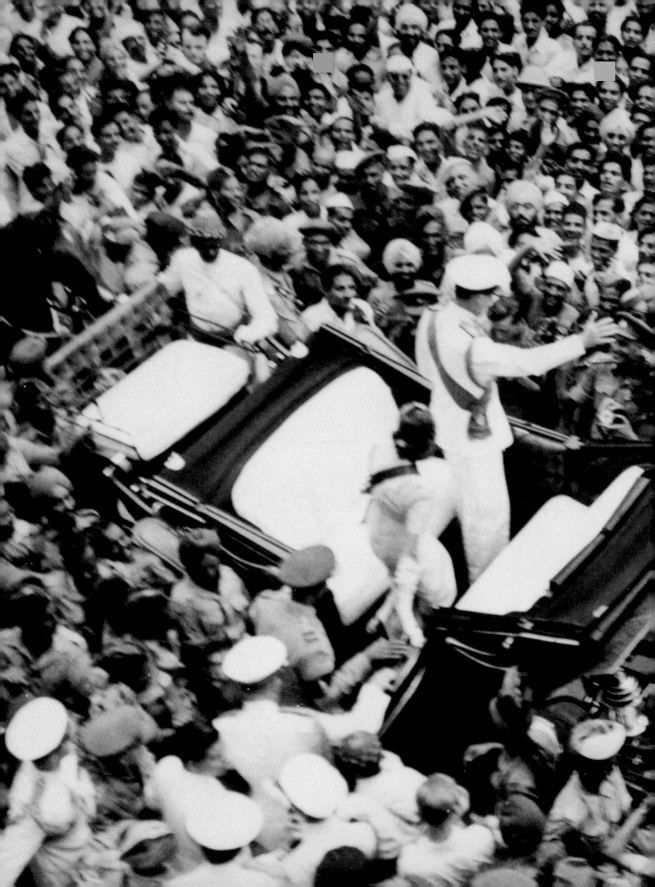

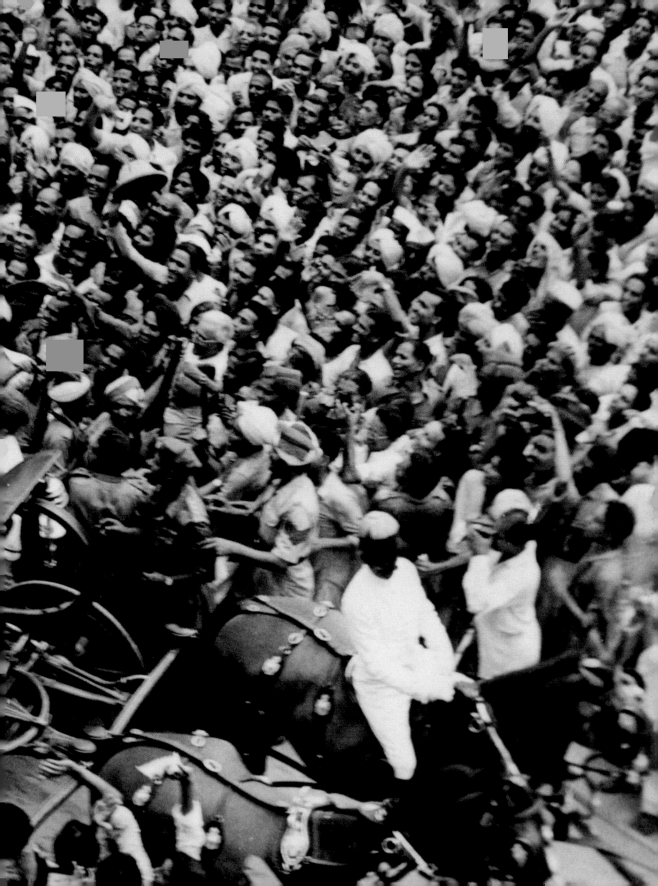

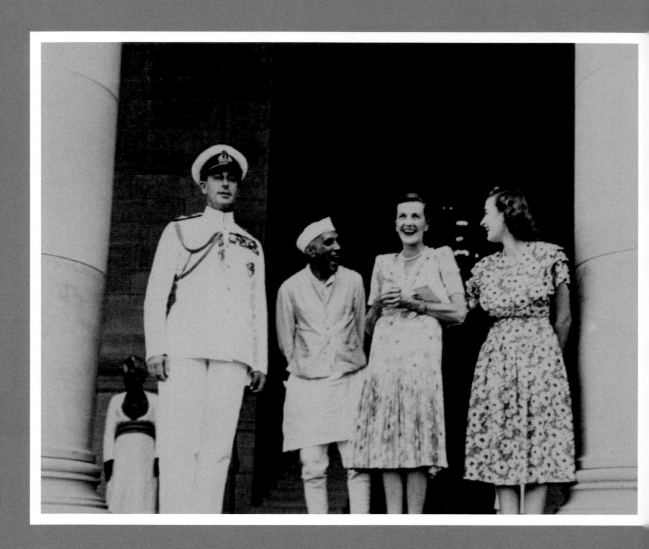

Part II

The First Governor-General of India

Left: Awaiting the arrival of my father's successor, Rajagopalachari.

Chronology of Events

August – September 1947	Rioting throughout India and Pakistan, as refugees from both countries seek safe passage to their new homelands.
29th August	Mountbattens travel to Simla for a 10-day stay, formally signifying Mountbatten handing the reins of leadership to Congress.
5th September	Mountbatten asked to head up an Emergency Committee following spiralling violence and civil disobedience.
6th September	News reaches Delhi that Gandhi's single presence in Calcutta is miraculously keeping the peace there.
13th September	Pamela starts working in the Map Room to help with the crisis.
October – December	First Kashmir War.
9th – 24th November	Mountbattens travel to England for Princess Elizabeth's wedding.
24th November	Emergency Committee disbanded.
December – 31st January	Mountbattens start their hectic tour of the provinces and states with the intention of visiting all of them before they leave.
13th – 18th January 1948	Gandhi's last fast.
20th January	First attempt on Gandhi's life.
30th January	Gandhi assassinated.
31st January	Funeral and cremation.
1st February	First Governors' Conference after Partition, now with Indian Governors.
February – May	Mountbatten family continue their tour schedule.
20th June	Last State Banquet.
21st June	The Mountbattens return to England.

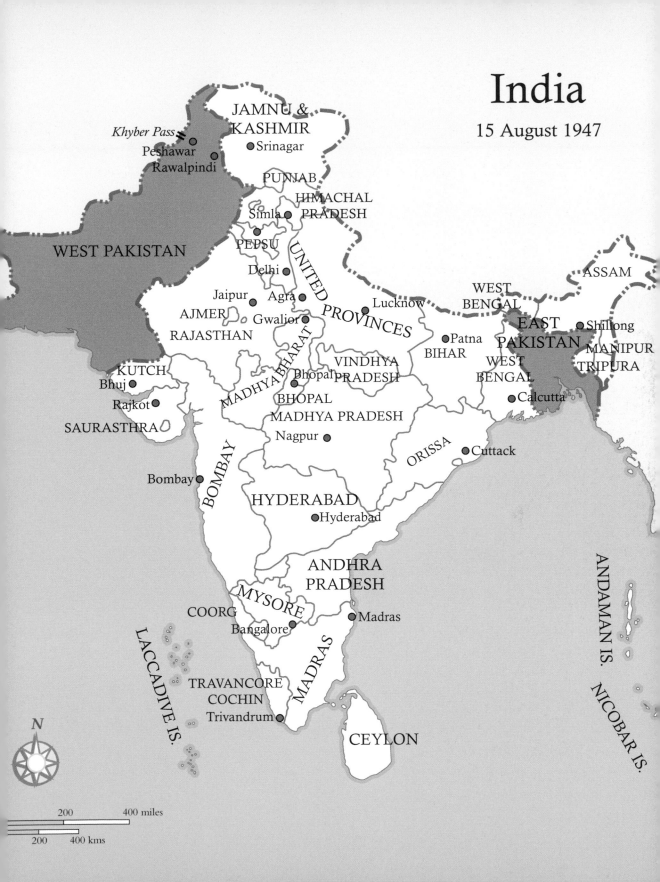

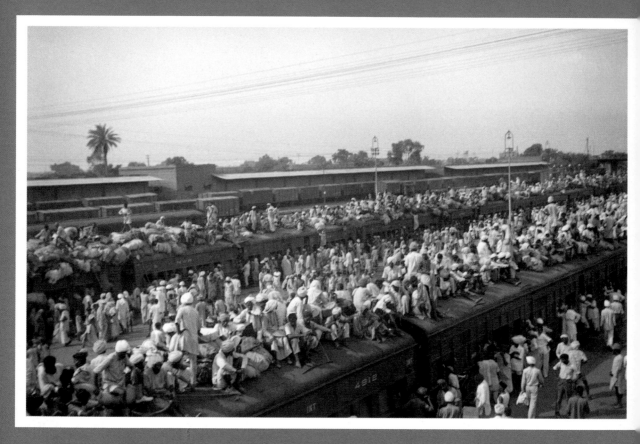

October 1947: Indian refugees crowd onto trains in one of the largest transfers of population in history.

Riots and Refugees:

August – November 1947

Following a phonecall from V.P. Menon, we came back to Delhi.
We thought at first that Nehru and Patel had requested that my
father return to help, but this turned out not to be the case and
they were furious. However, very quickly they came round to the
opinion that my father could help and he immediately set up the
Emergency Committee. My mother launched into action to tackle
the refugee problems where she could, taking in another 5,000
people on the Estate and putting the whole of the Governor-
Gerneral's house on tight rations of spam and cabbage soup. She
wrote in her diary that 'Pammy has become quite fond of SPAM!'
although I must admit that I thought bully beef was better.
I started working as Pete Rees's PA in the Map Room...
Meanwhile Gandhi, purely through his presence in Calcutta,
galvanised peace across what could have been the most incendiary
city. My father called him a 'one man boundary force...'

Saturday 16th August
I went with Mummy and Panditji to watch him hoist the flag on the
Red Fort in Old Delhi while a crowd of at least 800,000 people watched
below. He spoke to them and they sang popular national songs and there
were guards of honour.
This afternoon Daddy showed the leaders the Radcliffe Award
[following Sir Cyril Radcliffe's recommendations for the boundary
lines] *and there was a conference in the Council Chamber.*
Liaquat (Ali Khan who is now Premier of Pakistan) came to dinner as
discussions are resulting in them having to call a conference in Ambala
due to the terrible conditions in the Punjab. This is all added to the
profound worry resulting from the Boundary Commission Award.

'Her tour of the Bombay slums was characteristic
of her thoroughness and serves to explain the
tremendous popularity she has gained for herself
with the humbler Indian people.'
Alan Campbell-Johnson on Lady Mountbatten

Sunday 17th August
We left for Bombay at five in the morning in order to arrive in time to see
the first contingent of British troops embark on the 'Georgic' at 10 o'clock
to return home. Government House is a series of charming little
bungalows with Point Bungalow looking out over the sea. We went to
a big reception at the Taj Hotel given by Kher, the new Premier of
Bombay. There had been no publicity about it but once we were inside
word got round that the new Governor-General was inside and a crowd
numbering three quarters of a million gathered outside. It took us over
an hour to drive back through the cheering crowds, a distance which had
taken fifteen minutes before.

I stayed in Bombay to accompany my mother and also I had
an appointment of my own to meet Dinkar Sakrikar. I had been

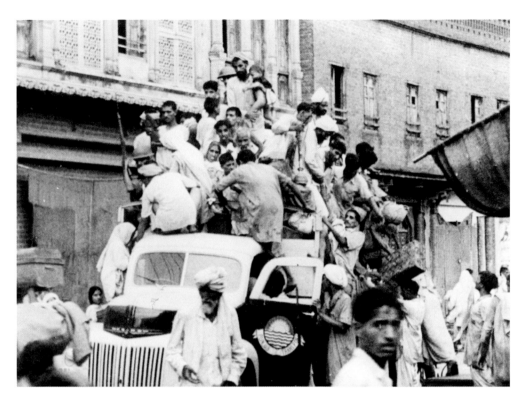

5th September 1947: Armed soldiers join Muslim refugees as they crowd one of the very few modern vehicles on the trek to the Muslim state of Pakistan.

told that he would be very difficult to get hold of because he had only just been released from prison. I had also been warned that he might not want to meet me and that he would certainly be averse to meeting at Government House considering what it stood for. The chaos that followed the arrival caused me great embarrassment but again I was amazed by the Indian character.

Monday 18th August
Daddy had to return to Delhi.
I went with Mummy and Lady Colville on an exhausting but extremely interesting tour in the morning. We visited the Bombay Mothers and Children Welfare Society's Centre and then its school. Then the Naigum

Social Service Centre, and the Matunga camp, where all the workers live in the most appalling slum conditions. Then on to the University Settlement for Girls, the Tata Institute of Social Services and the Siva Sadar domestic college, all in monsoon downpours, so we ended up soaking wet and covered in mud.

Dinkar Sakrikar, the student leader connected with the Asian and Congress Students' Conferences I have been trying to contact, came to have tea with me and brought half-a-dozen other students with him.

In spite of the students having been kept for twenty minutes in the guard house, while I was wondering why they were so late, they could not have been more charming and friendly. They were only released after I had telephoned down to the ADC's room several times asking them to ring through to the police box. It turned out that the police who detained them were the very same ones that had arrested them and they had all had a very enjoyable time reminiscing together, which could only happen in India.

Tuesday 19th August
Dinkar Sakrikar's student friends called for me in the early morning with an enormous car covered in Dominion flags and took me to see their institutions. We went to the big G.S. Medical College and then to Bombay University and finally to the J.J. School of Arts, which was fascinating. Tore back dripping with bouquets, garlands and presents only to find that we could not fly owing to the bad weather.

Wednesday 20th August
We spent a quiet morning reading and writing and saying goodbye to all the Governors and wives who are sailing for England. Eric [Mieville] arrived on his way back to England, which is very sad but he really is not at all well.
We were able to take off at mid-day.

Friday 22nd August
In the evening we had Panditji to dinner with the author, producer and
director of the famous film he wanted to see, Neecha Nagan. It is being
fought over in the law courts but it is very good and really the first serious
Indian film.

Saturday 23rd August
Spent the morning writing and playing with the mongoose who
has become the greatest 'time waster'. We had lunch at the pool.
In the evening I went to the Canteen. We had the first Indians to have
come in for a long while. They were very self-conscious but hopefully more
will come as they are starting to mix and the prices have been lowered so
as to be more affordable for them.

Sunday 24th August
I spent a large part of the day battling between a firm Ronald Daubeny
trying to 'Comptrol' eight hundred applicants into forty vacancies
(the servants who have left for Pakistan) and a tearful and unbelieving
Lila Nand intent on getting his younger brother, Amla Nand, a job.
(We succeeded.)

My mother left on a three-day tour with Rajkumari Amrit
Kaur, the Minister for Health, a Christian and long-time disciple
of Gandhi. My father and I did at least get to spend a little bit of
time together alone – a rare treat indeed as there had been
precious few moments like that in the last five months. Mummy
reported the horrors – her PA, Muriel Watson, called it the 'place
of the dead' and was quite upset. They found mass hysteria and
no trust in the Punjab Boundary Force. My mother also managed
to secure an interview with Master Tara Singh who was 'at last
beginning to tremble at the wrath he had so readily invoked'
in the Sikh community. My father's executive responsibilities
were over as the Punjab Boundary Force and the Joint Defence
Council's authority over it had been wrapped up, so we went to

Simla to reinforce the idea in Congress's mind that his day-to-day contact with government was over. My forlorn prediction that my parents would probably be working was prescient – most family meals were taken with them looking at paperwork on their knees.

Monday 25th August
I worked at the Clinic.
Mummy is leaving for Lahore and Amritsar tomorrow to see the refugee camps which are said to be in complete chaos. The situation in the Punjab and Bengal is really terrible. I hope she survives. Baldev Singh, on his tour round, was shot at by the police in mistake for a raiding party.

Tuesday 26th August
I went for a long ride with Daddy in the morning. And we had meals alone upstairs which was nice.

Wednesday 27th August
Mummy rang up last night to say that she was staying a day longer so that she can go to Rawalpindi and Amritsar as the situation is so appalling.
Bikaner came to dinner as well as Walter Monckton and Biddy Carlyle, now Lady Monckton.

Thursday 28th August
I went to the Clinic as usual. Then there was a terrible lunch party – very heavy weather with long silences and completely mute non-English-speaking women and my Hindustani quite inadequate.
Mummy came back with the most horrifying and heart-rending accounts.

Friday 29th August
We left to spend ten days in Simla. A very welcome holiday for all and well deserved for Mummy and Daddy although I am afraid that they will probably work all the same.

*The river is in flood now which makes the journey very complicated
and tedious.*

*We flew as usual to Ambala where we picked up Daddy as he had gone
on ahead for the conference at Lahore* [the Joint Defence Committee
Conference to discuss the fate of the Punjab Boundary force: 55,000
troops had tried to control the slaughter with little result], *we went
by train to Kalka and then the railcar. The rest of the party had gone on
by road but were held up whenever the 'Royal Train' passed the points
where the railway closes the road, so there was a lot of hilarious waving,
cheering and saluting.*

Saturday 30th August
*It really does feel wonderful to be in Simla again and it seems quite
extraordinary having everyone so good tempered again.*

'Lazed in bed all morning!'
*Louis Mountbatten's diary entry on
the first morning in Simla*

*Mummy and I were very energetic and walked Mizzy for miles and miles
up and down the hills.*

*We have also brought the mongoose in his little wooden box, loudly
protesting. But he is in fine form now as he is incurably inquisitive for
new places.*

*We went to see 'Jane Steps Out' at the famous little Simla Amateur
Dramatic Company's theatre. It was very good.*

Sunday 31st August
*The nearly engaged couple, Sarah Ismay and Wenty Beaumont, came
to dinner. He is leaving for Bombay to become Comptroller ADC to
the Colvilles.*

Monday 1st September
The Chief, or rather Supreme Commander Field Marshall Auchinleck,
came to lunch with his sister Cherry Jackson and her son who is now 'the
Auk's' military secretary. In the afternoon we went shopping in Simla and
then for a drive round Jacko Hill but got ignominiously stuck round a
narrow bend and had to bale out and walk back for miles through the
town which was much more fun!

Our happy relaxed holiday was short-lived. We had only been
in Simla for three days when the bad news started to flood in:
firstly the shocking news of the carnage on the train taken by
Sarah and Wenty, and then the horrific news of the death of our
old Treasurer and his wife and son brought the horror of the trou-
bles very close.

News came through that the train Sarah and Wenty went down on was
stopped and attacked (the first on the Simla line) and 150 Muslims were
killed. The only one to survive was Wenty's bearer, hidden under their
seat. They swore that there was no-one else in the compartment.

Tuesday 2nd September
Last night the old Treasurer's son was killed returning from college in
Delhi. Against all persuasion his parents left for Delhi by train this
morning. They were both murdered on the way in spite of the Hindu
chaprassi with them haranguing the crowd on their behalf that they were
citizens of the Union of India with fifty years government service. He
himself arrived naked, stripped as a suspect Muslim. There seems no end
to it all as it is just retaliation after retaliation. But one can hardly expect
them to keep their senses when they have experienced such atrocities.
Unfortunately it is always the wrong people who suffer. However, the
situation in Bengal is better although the Punjab is still terrible.

Wednesday 3rd September
Last night we had dinner with the Auk. Compton Mackenzie was there

With the cast of "Jane steps out" at the Simla
Amateur Dramatic Society (oldest A.D.S. in World)
30th August

and we watched coloured films of his trips to Nepal and Tibet including
good close-ups of a tiger.
This evening Jim and I went to dinner with Shou Shou and Moumou,
two of the married daughters of the Tikka Rani of Kapurthala and
very charming.

Thursday 4th September
V.P. rang up at lunch time to say that the situation is deteriorating
and they feel it would help if Daddy came back to give advice at once.
We never seem to have much luck with our holidays.
All proposed tours have been cancelled and it has been announced that
we would neither give nor attend social gatherings or entertainments.
In spite of this, I nipped out to have tea with Shou Shou and Moumou
and they came back and had dinner with us.
I had a very sweet letter from Lilibet about bridesmaids' dresses and
the wedding.

Friday 5th September
We motored down to Ambala in an open police car as ours is still somewhere between Delhi and Karachi as it has never returned from the ceremony. We were a very make-shift party as we took no Muslim drivers or servants and most of the ADCs and staff were driving. My Lila Nand is in his element looking after two Excellencies.
We are now faced with the problem of getting eighty Muslim servants and personnel down as well as 150 Hindus and the European staff. They are going in trains under armed escort of the Bodyguard and then flown in batches.

Saturday 6th September
The news from Calcutta is that Gandhiji's presence there is managing to keep the peace – which everyone describes as a miracle.

Sunday 7th September
There was a stabbing on the Estate today.

Campbell-Johnson writes on 8th September, that he was told by Peter Howes, the chief ADC, that among all the ADCs, 'attendance of Lady Mountbatten is hardly the most popular [as] it usually involves assisting her to bring into the local infirmaries any bodies they may see in the streets. She is not deterred from [doing so] even when passing through areas where sniping is going on.'

Monday 8th September
I could not go to the Clinic as Daddy said if I went out I should take a guard (which I naturally would not do as they are needed desperately everywhere else). Anyway, the Canteen is closed and we have very few patients at the Clinic as no-one can get about now.

Tuesday 9th September
Mummy spent most of her time tearing round the hospitals trying to get

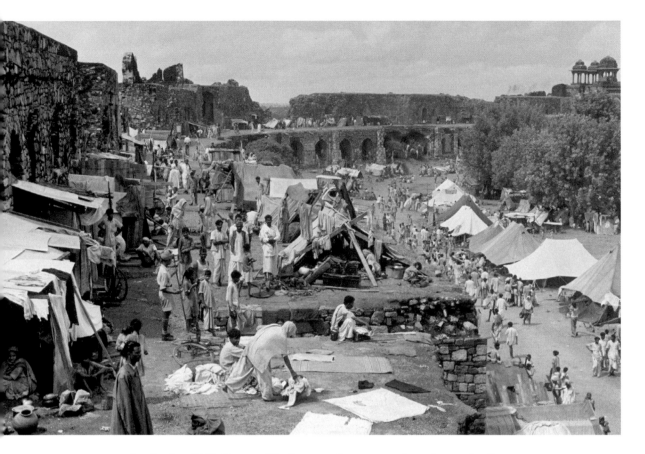

1st October 1947: Purano Qila fortress refugee camp where thousands of Muslims who had fled their homes in terror of Hindu attacks were trying to survive until they could organise a convoy for the long march to the West Punjab, which had become Muslim Pakistan.

*them guards, food and fuel and help with the refugee committee.
Daddy went to see Gandhiji who is returned from Calcutta.*

Wednesday 10th September
Food is now the immediate and major problem. The shops are mostly shut because of the curfew and when open have no supplies because there is no way they can be brought in and all the labourers and workers have taken flight.

I went with Mummy to see the rationing centre where we try to feed the 5,000 people on the Estate. When they do get their food they often can't eat it as there is no fuel. In the house all meals are very meagre and our rations will only last for a week as there are no surplus stores.
Lord Listowel arrived [Secretary of State for India] *– not a very good time to choose but at least he will get first-hand information which is invaluable at a time when newspaper scares are rampant.*

We took an extra 5,000 people into the Estate and food supplies were short.

When my mother flew up to the Punjab in the worst of the riots she took Captain Jim Scott – one of Wavell's old ADCs – and an Indian ADC who had been lent by the Army. They were driven from Viceroy's House to Palam Airport to be greeted with a message from the Governor of the Punjab who had telephoned, and a signal had been sent also, saying that it was imperative she did not travel as the situation was too dangerous. But my mother merely said that it was imperative that she go, they were already late and so they must take off immediately.

After a couple of hours they were circling over the landing strip and saw an enormous number of people, a lot of them Sikhs with their religious weapons, the kirpan. Everybody was milling around in agitation, protestors were shrieking and it became immediately apparent that it was a very disturbed, threatening crowd.

When they landed, Jim Scott looked at the young officer and patted his revolver; he admitted that he had never had to shoot in anger, but this might have to be the first time. My mother rushed ahead and as they watched half a dozen leaders detached themselves from the crowd and headed towards her with the crowd following. The two ADCs said that they saw danger, they saw anger, they were absolutely terrified and, although she had forbidden them to go with her, they were about to leap forward and follow.

At that moment my mother held out her arms and the leaders stopped for a moment. She moved on and they put their weapons down and put their hands out to her. 'She saw love, she didn't see danger,' was how they described it. 'And the crowd saw love. And they hugged and they embraced and everybody was hugging and embracing and they took her into the camp and, she did the work she came out to do in the camp.' They said it was the most extraordinary performance, that there was no question that she was afraid or being brave, it was just she had a job to do.

In a letter to my mother dated 10th September, Sarojini Naidu, the daughter of her mother's old friend, and Governor of the United Provinces, wrote to her: 'No woman in your place has ever put herself in touch with the people... the last of the Vicereines is creating her own immortality in the hearts of suffering India.'

Thursday 11th September
Yesterday, we went to see Martin [Gilliat] *in hospital. Tuesday night he and Alan Campbell-Johnson* [went] *to see whether the guards had at last been put outside the hospitals when they were shot at by a sentry – over enthusiastic with regard to the 'shoot on sight' orders which are in force. The driver was killed outright and Martin was wounded, however, luckily not very badly...*
Spent most of the day catching glimpses of Mummy and Daddy tearing in and out.

This incident really drove the message home to us all that we should be very careful and my mother was told she must have an escort. One evening she came back from old Delhi and said 'Dickie, I do actually think you are right because I was quite frightened to see I was being followed by a car with the most terrifying ruffians in it, with their rifles sticking out...' My father had to smile to himself, because that car *was* a security car with plain clothes police.

Friday 12th September
The situation in Delhi seems much better now and almost under control.
The shops and offices are opening and very few incidents have been reported;
but the curfew is still very strict and the streets almost deserted. Lord Listowel
and party left after having been fed entirely on spam and bully beef.

Saturday 13th September
I spent the morning writing and then in the afternoon started my
first 'job'.
General Pete Rees (of Gurkha fame from the Burma Campaign, where
he commanded the Dagger division) has arrived. He had been
commanding the Boundary Force but this has now been disbanded.
He has now set up a Map Room, a sort of war room for information
and conferences to deal with the present crisis. (He will head the Military
Emergency Staff). However, very few of his staff have arrived, just two
British officers and four Indian. He has no secretary and only a part-time
stenographer. As he is swamped with work Daddy has told me to help
out. I spent the afternoon telephoning, typing lists and notes, sending
messages and being the General's dogsbody. Rather alarming to begin
with but very interesting and it feels so good to be doing something.

Sunday 14th September
We work in the Map Room from nine to one and two to six, including
Sundays. I had to type letters and papers and make arrangements
and a lot of telephoning. After dinner a film was shown in the cinema,
which we do as often as possible. Tonight it was 'The Web' which was
excellent. That was a relief as it was one of my selections.

Monday 15th September
The conferences in the Map Room have been reduced in number as there
really were too many. Now there are just Cabinet ones on even days, two
a week for the Diplomatic Corps and although there is a daily press
conference, General Rees only conducts one of these each week. I only
attend the Cabinet conferences. The 'undiluted accounts' are obviously

extremely interesting. It is difficult getting used to all the Army terms and having to cope with GIs and GIIIs etc. when one is given a string of initials over the telephone it is hard to turn it into an individual. Anyway the telephone is not much use as nearly all the operators have gone and so most have been disconnected.

Tuesday 16th September
I spent most of the day working in the Map Room.
Cholera and a few cases of smallpox have broken out in the refugee camps and we all had to have cholera inoculations.
I went with some of the staff to have dinner with the Ismays. Very enjoyable and masses to eat as they have paid no attention to rationing – really rather naughty under the present circumstances, but I suppose that we are rationed particularly strictly as the staff is so large that it does make catering difficult.

Wednesday 17th September
I have had to give up the Clinic and the Canteen for the time being as they don't fit in with the Map Room hours. Mr Lal came to see me about the Hindustani lessons as they are going to be difficult to arrange, particularly as he cannot come during curfew hours.
Daddy and I went for a short, quiet ride in the grounds as the horses are not fit as they have had to be turned out as fodder is so scarce.
Nevertheless they were maddening through lack of exercise. I went with the General to a cocktail party given by Major Thakar, one of our staff, who is leaving for China as Military Attaché.

Thursday 18th September
A Dr Eugene Bartlett, head of all the American YMCAs, was down in the arrangements as staying. But he has arrived and could not have been nicer – which is a very pleasant surprise – although just why he is staying no-one can quite make out!
One of life's endless knitting campaigns has started. This one is for the refugees, against the coming weather. The needles are home-made wooden

ones and the dye from the wool comes off on one's fingers so at least it is different.

Friday 19th September
Both Prime Ministers, Liaquat and Panditji, came to supper.

Sunday 21st September
Mummy and Daddy flew off with Panditji, Vallabhbhai Patel, Rajkumari Amrit Kaur, Pug Ismay and Alan C-J to survey the movement of refugees in the Punjab.

Monday 22nd September
The Emergency Cabinet is making urgent moves to defend the refugee trains as the horror stories get worse and rumours only fuel the violence.

Tuesday 23rd September
Cholera has broken out in Amritsar and all trains passing there have been cancelled. There are horrible stories around of trains which set off with thousands of passengers arriving with merely hundreds alive.

Tuesday 30th September
There was a senseless attack on the defenceless patients in a hospital in Delhi today.

The Creation of Lady Earnestine

At the beginning of October I wrote to my friend Mary in England: 'For the past six weeks we have been living on spam and bully beef, Delhi has been under martial law in all but name, and the refugees keep pouring in to a city where there is no means of receiving them. Delhi has been bad but it is nothing compared to the situation in the Punjab. It is heartbreaking to see

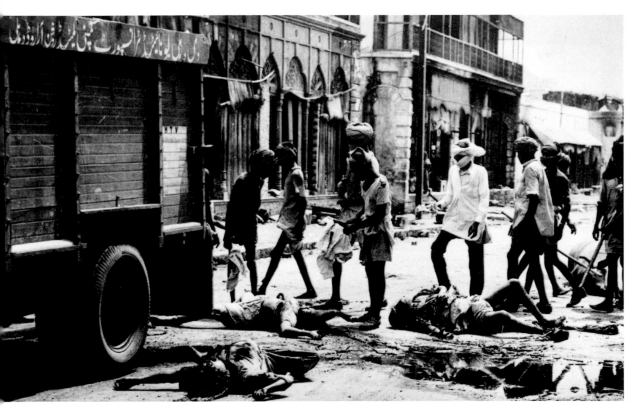

*October 1947: The bodies of those who were killed in the riots in
New Delhi are loaded into trucks during a lull in the fighting.*

so much destroyed in so little time that will take so long to
rebuild, and all for no real reason. It is senseless, but one sees no
end except by gradually wearing itself out as it is just retaliation
after retaliation.

A Military Emergency Staff has been set up under General
Rees and there is a Map Room to deal with the present situation,
gathering in all information and coping generally and giving
conferences to the Cabinet, the Diplomats and the Press. I have
my first job too now! They were very short of staff and so
I am the PA to the General, typing all his letters and papers,
telephoning, fixing things generally and getting thoroughly

bewildered by all the funny terms! However, it is extremely interesting and great fun but the hours are quite long being from nine to six (with an hour off for lunch) every day including Sunday, but the "six" is more often seven or eight as work just seems to pour in.'

Indeed, so serious was I by this time that when my sister and brother-in-law arrived in December they renamed me 'Lady Earnestine'. The progression of my employment from the Canteen through the Clinic to Pete Rees's PA in the Map Room, and my endless tours with my mother, and meeting with students had moulded a sternly serious eighteen-year-old!

In spite of this I was severely rebuked by the Prime Minister for being frivolous on one particular occasion. In the same spirit as people flocking to nightclubs to raise their spirits in wartime London, the Commander-in-Chief, General 'Kipper' Cariappa, started a nightclub in his house, to which the ADCs took me one night. It was my first taste of nightclubbing and I loved it. But Panditji got to hear and was shocked. He closed it down immediately.

Thursday 2nd October
We had quite a hectic day with work pouring in at the office and the telephone ringing ceaselessly but never functioning when one came to using it oneself!

Monday 6th October
Mummy and Muriel have left for Jullandur and Amritsar.

Saturday 11th October
We left to spend a few days in Simla which will be lovely. We are just going up alone except for Peter Howes, and will be staying at the Retreat at Mashobra.
We stopped off at the Lawrence Royal Military College at Sanawan on the way to celebrate its centenary.

Sunday 12th October
It really is glorious being up in the hills again and Mummy and Daddy
are actually able to take a little rest with nobody to get at them all the time.
We went for a long walk and met some of the mule caravans coming
along the Tibet road. We bought Tibetan and Nepalese ornaments and
jewellery and boxes from some peddlers.
The Captain of the Gurkha Guard is staying in the house. He is a
twenty-one-year-old boy from Ilford called Peter Pring. Extremely self-
possessed and adored by his Gurkhas.

Monday 13th October
Visited the famous Bishop Cotton School which is really the only first-
class civilian school in India for boys of every nationality and creed. Spent
part of the afternoon in Viceregal Lodge garden and then I had to go to a
tea given by the Simla branch of the Caravan of India. In the evening
we accompanied Daddy when he presented a shield to the Simla ADC.

Friday 24th October
Bad news from Kashmir as reports say that NWFP tribesmen are
marching upon Srinagar.

Monday 27th October
Indian troops have been sent to Kashmir to face the invasion of
tribesmen. Mummy left for a tour of refugee camps in West Bengal.

Thursday 30th October
Attended the International Labour Organisation conference in Delhi.

Saturday 1st November
Daddy has flown to Lahore to discuss the Kashmir crisis with Jinnah.

Sunday 2nd November
Maharaja of Bikaner came to dinner. He gave a speech with a film
describing about the refugees in his State.

E takes tea with Jawaharlal Nehru and his daughter Indira and her son during I.L.O. Conference – 30th October

There was so much trouble at this time that my parents were worried about leaving to go to Princess Elizabeth and Philip's wedding, where I was to be a bridesmaid. They were persuaded to go in order not to draw attention to the crisis.

30th October: With scouts and delegates to the International
Labour Organisation (ILO) Conference in Delhi.

Tuesday 4th November
Mummy and Daddy are worried about the trip to England for the
wedding and whether it should be cancelled because of the Kashmir
crisis. Baldev Singh's report from the front to the Defence Committee
was not at all good about the situation there.

*11th November: We were met at Northolt
by Philip on arrival in London for his wedding.*

Saturday 8th November
The Nizam of Hyderabad has asked for another delay in signing his standstill agreement until we are back from London!

Sunday 9th November
We flew back to London for Philip and Lilibet's wedding on the 20th at which I am to be one of the eight bridesmaids. Rajagopalachari will be Acting Governor General in Daddy's absence.

We returned to Delhi on the 24th after a hectic and amazing ten days. We had taken with us, as a gift for Princess Elizabeth and Philip from Gandhiji, a piece of white fabric which he had woven especially for them – when the gifts were displayed later Queen Mary was horrified to discover what she took to be a 'loin cloth'.

 Back in Delhi my father wrote in his diary, 'Lovely to be home.'

Friday 28th November
The Emergency Committee met for the last time today.

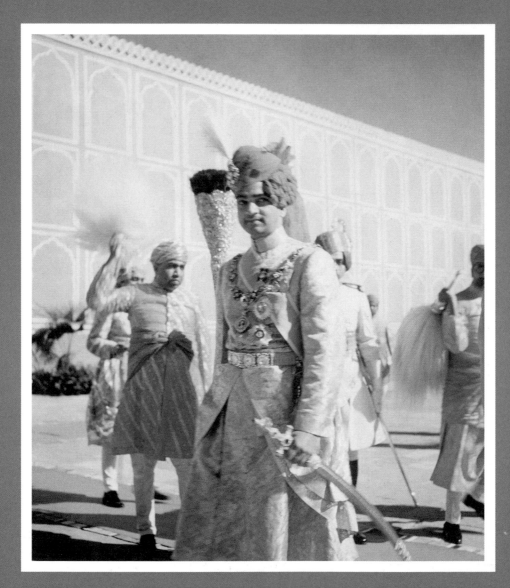

The Maharaja of Jaipur, or Jai.

Tours Part I: December 1947 – January 1948

We began our tour along with Patricia and her husband John: we planned to visit Jaipur, Bombay, Gwalior, Bikaner, Bhopal, Nagpur, Madras, Allahabad, Dehradun, Lucknow, Cawnpore, Calcutta, Orissa, Assam, Trivandrum, Travancore, Cochin, Udaipur, Mashobra, Simla, Patna, Gwalior, Mysore, Ootacamund, Bangalore, Jodhpur and Bundi, taking in a dizzying plethora of schools, colleges, hospitals, institutes and temples along the way.

Our friends also started to arrive as we had invited them out thinking that this would be a quiet period, hence we had Yola and Kay Norton in December, and Bunny and Gina Phillips in January and later Malcolm Sargent – unfortunately my mother was so busy with her various causes she found it very difficult to find time to see her friends.

12th December: My father inspecting the Guard of Honour,
1st Jaipur Infantry on arrival at the Maharajah's Palace.

Friday 12th December
To Jaipur for Jai's Silver Jubilee. We watched a parade of the Jaipur
Guards and Infantry. They are extremely smart and are drilled by NCOs
from the Brigade of Guards. Jai is a major in the Life Guards. He and
his regiment had a fine war record; a wonderful visit (he came to the
gadi when he was ten years old). Daddy played his first game of polo in
8 years. Daddy met the man who taught him to play in Jodhpur in 1921!

Talking with Hanut Singh, who
taught D. to play polo in Jodhpur 1921

D ↑ with his 30 goal side

P sitting next to the Maharajah of Kapurthala at the Durbar in the City Palace, Jaipur.

Sunday 14th December

Daddy invested the Maharajah with the GCSI [Grand Commander of the Star of India] *at the Durbar.*

The celebrations were magnificent with many other Princes attending. Jai looked marvellous bedecked in jewels, but it was quite a shock to see him sacrifice a goat during the religious ritual. And having only met the beautiful Ayesha it was a surprise to find that in the Zenana she, as Third Her Highness, is very much the junior hostess. Beautiful Jo Didi, Second Her Highness, is the senior Maharani. When Jai was 14 he was married to a princess from Jodhpur, 12 years his senior, and he was at the same time betrothed to her niece, Jo Didi, then only 5. They were married when she became 12. First Her Highness died 3 years ago but I very much liked her daughter, Mickey, who is my age, and her son Bubbles who is 16. Second Her Highness has two boys, Joey and Pat, a couple of years younger.

My parents and Jai – official investiture photograph.

Peggy D'Aremberg and a friend of hers came out for the jubilee and they brought a hairdresser with them. My father was very cross, thinking it very bad form when there were starving Indians all around, and the riots were happening. Other guests included Yola and Kay Norton who had once found her bearer looking through a keyhole into her room; when reprimanded, he replied quite obviously, 'but if I don't, how do I know when to go in?'

Thursday 18th December
We returned to Delhi. Patricia and John have arrived for a long visit, which is lovely.

Sunday 28th- Monday 29th December
A very enjoyable visit to Gwalior – for the famous tiger shoot.

Group photograph taken after the Durbar.

Saturday 3rd January, 1948
Private investiture for small party on the New Year's Honours list.
To add to her GBE, which Mummy got at the end of 1947, she now has
the Brilliant Star of China. Campbell-Johnson and Vernon got the CIE
and Ronnie Brockman the CSI.

Sunday 4th January
Burma Independence Day. Daddy and the Ambassador took part in a
particularly elaborate presentation with much pomp and ceremony in the
Durbar Hall. Daddy presented the Ambassador with an historic Burmese
Taktaposh and carpet. He also announced that he would be paying an
official visit to Burma in March, when he would hand over the immense
throne of King Theebaw, the last King of Burma.

Saturday 10th January
A large dinner party for all the Princes to whom Daddy has been speak-
ing in two conclaves this week, one for the major and another for the
minor Princes.

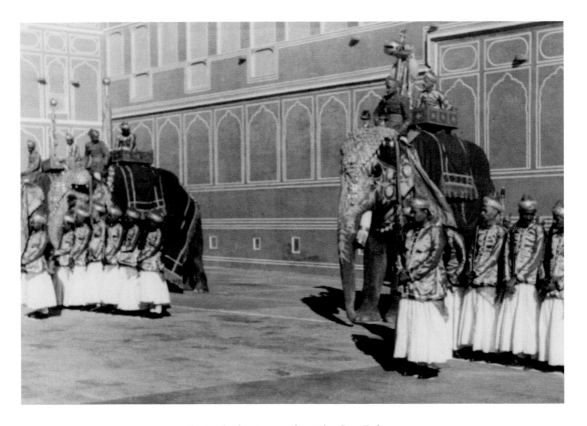

State elephants parade at the City Palace.

This was my father's last attempt to see that the Princes were left as secure as possible and that they would be well enough informed to look after their own fate. They felt rather desolate when my father left and wondered how they would cope with being part of the future in a very socialist-minded state. My father had encouraged them to make themselves available for senior positions. Indeed the Maharajah of Jaipur became ambassador in Spain and then became Rajpramukh – the senior Governor over a huge province. And Patiala became the Chief Minister in Patiala State. Several indeed were thus employed. One of the junior Princes, who was a favourite of my father's, was the Rao Raja of Bundi. He was a handsome, gallant young man who had won an MC in the war. My father took

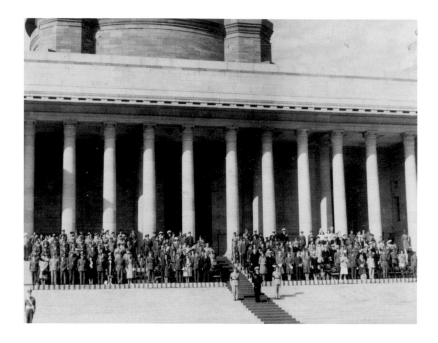

My father taking the salute at the farewell parade of British troops in Delhi in front of Government House.

us on a brief visit to Bundi in 1948 and was always glad to see him. However, on one of his later visits, after India had become a republic, he was at a formal dinner party at what was now President's House and he noticed Bundi, as an ADC to the President, not seated at table as he would have been as an ADC in our time, but standing behind the President's chair. After dinner my father received a message asking whether His Highness could see him. My father agreed with some trepidation, expecting Bundi to complain, instead of which Bundi thanked him for having encouraged him to offer his services to the President and to say how proud he was that they had been accepted.

About ten years later Bundi was in England and my father invited him to lunch at Broadlands. After lunch they were sitting talking in the drawing room. Bundi suddenly leant towards my father, who also leant forward, thinking that Bundi wished to say something

John, Patricia and me at the parade.

very confidential. But Bundi leant further and further until he fell down dead at my father's feet. My poor father was so astonished and appalled that the only thing he could think of doing was to telephone the Queen for help. When she answered he said, 'I have just had Bundi to Lunch.' 'How is he?' asked the Queen. 'Dead,' replied my father. But of course, she was magnificent and she saved the situation.

Then there was the news of Gandhiji's proposed fasts because of his distress that Congress were withholding fifty-five crores from Pakistan's partition of assets as a sanction. His fasts were incredibly powerful social catalysts, as Alan Campbell-Johnson wrote on the 12th January, 'You have to live in the vicinity of a Gandhi fast to understand its pulling power. The whole of [his] life is a study in the art of influencing the masses, and judging by the success he has achieved... he must be accounted one of the greatest artists in leadership of all time.' It was decided that we would still all travel to

Bikaner on the 14th but, as a mark of respect for the fast, there
would be no state banquet.

Monday 12th January
*After Gandhiji's prayer meeting he came round to see Daddy to tell him
that at 11 o'clock tomorrow will begin another of his major fasts, his
decision made in the face of the communal hatred which he has fought
all his life to remove from society. It would only end 'if and when
I am satisfied that there is a reunion of hearts of all communities
brought about without any outside pressure but from an awakened
sense of duty.'*

'Gandhi... must be accounted one of the
greatest artists in leadership of all time.'
Alan Campbell-Johnson

Wednesday 14th January
*A party of 28 flew to Bikaner to stay with the Maharajah. Daddy first
met him when he was 7 and Hiru was 5 and then 4 years later at the
coronation of King George V. Both of them served on the staff of
the Prince of Wales for his visit to India in 1921/22. A 60-page
programme has been prepared for our visit but the State Banquet has
been cancelled out of respect for Gandhiji's fast. We drove straight to
Gajner, HH's shooting estate, where a mile-long lake has been carved
out of the Rajputana desert. When we arrived at the Lagoon Terrace
the programme read 'The Master of the Household will take the
necessary steps to ensure that the crows and other birds are not allowed
to settle on the trees on the Lagoon Terrace for at least a week beforehand
and special care must be taken about this on the day of the lunch.'
In the afternoon there was a vast duck shoot. We had dinner in a silk-
lined and carpeted shamiana and then watched HH's sporting films
from around the world.*

Left to right: John, Patricia, my father, Bikaner, my mother,
the Raj Kumar and me.

Thursday 15th January

At 7:30 this morning we had the famous imperial sand-grouse shoot.
30,000 birds flew over during the morning. They are difficult to shoot,
flying very fast and swerving in all directions. In the afternoon we drove
25 miles to Lallgarh Palace in Bikaner. Before dinner we gathered in the
Durbar Hall where Daddy invested HH with the Insignia of the GCSI.
The assembled nobles and courtiers looked very fine in their red and
yellow Durbar dress.

Friday 16th January

A review of the Bikaner State Army including a trot past of the Camel
Corps and a gallop past of the Durbar Lancers. The Bijey Battery on
parade served with great distinction in Daddy's Burma Campaign and
fought in the battles of Kohima and Imphal. We then visited the Fort
where we saw regalia given to the Bikaner rulers by Moghul Emperors
and we were shown beautifully illuminated Sanskrit and Urdu manu-
scripts. Afterwards we drove through the city past enthusiastic crowds.
In the evening we watched a tournament in which the Bodyguard and

23rd January: Hamidulla Khan, the Nawab of Bhopal with my mother.
My father with Bhopal's daughter and the Nawab of Pataudi.

the Camel Battery gave an excellent musical ride and drive followed by
torch-lit club-swinging. We then returned for a large dinner party in the
Durbar Hall.

Saturday 17th January
We flew back to Delhi and Mummy and Daddy immediately called on
Gandhiji at Birla House. They found him very weak. But he greeted them
with a twinkle in his eye and said, 'It takes a fast to bring you to me.'

Sunday 18th January
Gandhiji has broken off his fast as Congress has decided to pay the crores
and they have persuaded him that his other anxieties have been dealt with.

Tuesday 20th January
Mummy rushed round to Birla house to see Gandhiji after a bomb
exploded in the garden as he walked to his prayer meeting. Gandhiji
seemed very relaxed about the whole affair.

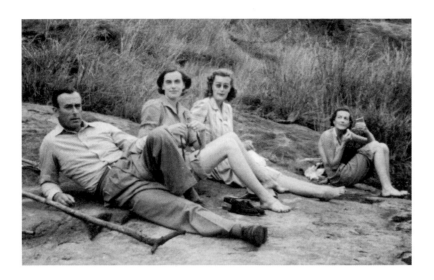

The Family relaxing in Bhopal - 25th January

Friday 23rd January
We visited Bhopal, whose Nawab is Daddy's old friend, Hamidullah.

Tuesday 27th January
We visited Nagpur and then flew on down to Madras which we toured and went up to the hill station, Ootacamund. The Governor Sir Archibald Nye, took us out riding. We were warned to follow him in single file, along a narrow bank. Daddy was on a large, clumsy horse which missed its footing and he ended up in the bog. He was pulled clear but it took an agonising time to remove Daddy's beautiful but sodden leather boots, made by Maxwell to hug the legs, and to get him into morning coat and top hat.

Friday 30th January
We arrived back in Delhi.

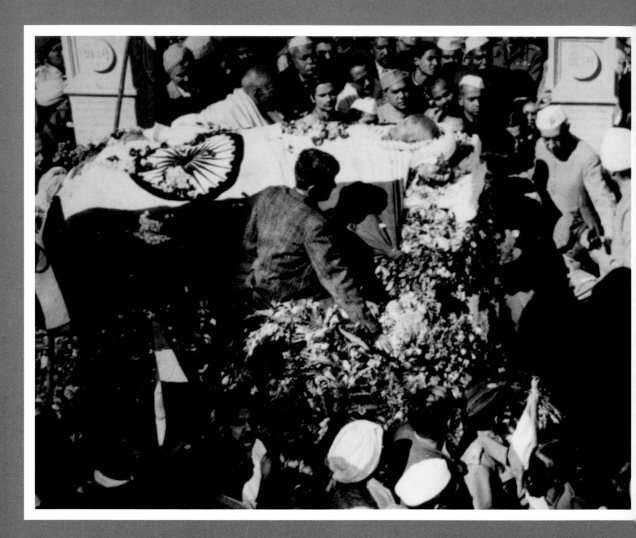

Gandhi's body brought out of Birla House.

Gandhi's Assassination:
January 1948

Such was Gandhiji's standing in India that my father had made sure
that a meeting with the great man was one of the first things on the
agenda when we arrived. As the months slipped by, Gandhi's political
opinions became eclipsed by those of Congress and the Muslim
League, but the aura that surrounded him was no more diminished
for that. I had the incredible good fortune to attend one of his
prayer meetings and meet him on several occasions. I, like the rest
of India, revered him. His assassination brought the whole of the
nation to a standstill and we all felt the blow cruelly.

Gandhiji's Assassination

Friday 30th January

Daddy, Patricia, John and I arrived back in Delhi this afternoon from a visit to Madras. Mummy stayed on to complete her engagements. A couple of hours later I was standing in my bedroom with the radio turned on when suddenly there was an announcement: Gandhiji had been assassinated. I couldn't believe it. I was dumbstruck, but the announcement continued. He had been shot while he was walking to his weekly prayer meeting. By now, tears were pouring down my face.

I had only met him a few times but I felt as though I had lost a member of my family. And so did everyone else in India. Bapu, the Father of the Nation, was dead. The whole of India seemed to have come to a complete standstill with everyone engulfed by horror and grief. But my father dashed to Birla House.

As he got out of the car, someone in the crowd shouted out to him, 'A Muslim did it.' My father had the presence of mind to shout back, 'You fool, it was a Hindu!' In fact, no one knew who the assassin was. But my father felt instinctively that his reply was the only way to prevent a disastrous civil war.

He was immediately taken to Gandhiji's room, where the body had been placed. My father told us that he stood in silent homage and then went into another room where the members of the Cabinet had gathered. He told them that at his last interview, Gandhi had said that his dearest wish was for a reconciliation between Panditji and Vallabhbhai Patel – he had been very distressed by their bitter disagreements. Panditji and Sardarji immediately and dramatically embraced. My father came back greatly relieved at this reconciliation.

Of course the next preoccupation was Nehru's safety. The new India now relied on him – he was the pivot and vital as much the strongest man. My father was convinced that there wasn't a sole assassin because they had found three people carrying grenades only three days earlier and my father thought that Nehru was the target.

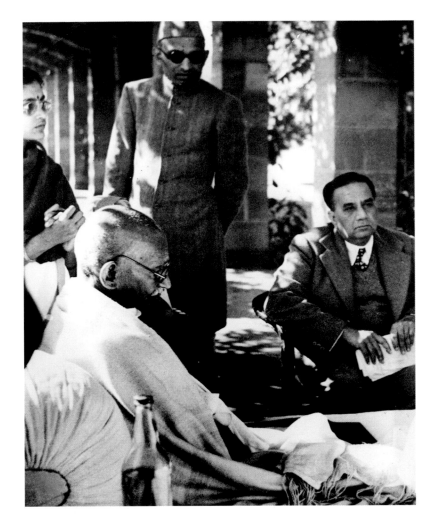

17th January: Mahatma Gandhi at Birla House, New Delhi,
during his final fast.

He also thought it essential that Nehru must have time to work
out what he was going to say in his broadcast. In fact, the slightly
impromptu tone and the raw voice were very moving. Panditji's
broadcast to the nation was followed immediately by Vallabhbhai.
Patel spoke very well but no one who heard Panditji's speech –
'The light has gone out' – will ever forget it.

Saturday 31 January
Mummy flew back in the night and arrived in time for breakfast, after which
we drove to Birla House.

Gandhi's body had been placed on a balcony. He looked very
serene with his head resting on a cushion of flowers, but without
his glasses he seemed rather unfamiliar – very small and frail.
It was heartbreaking and of course everyone around him was
weeping. My father and Panditji tried their best to control the chaos
when his body was brought down from the balcony and placed on
the bier. The Congress flag covered the funeral carriage, which was
pulled by sailors with the Governor-General's bodyguard as escort.
The procession to Raj Ghat, the burning ground, a large open space
on the banks of the river Jumna, wound six miles long through old
and New Delhi. The route was lined by soldiers, sailors and airmen.
It must have taken a lot of organisation in the few hours since
Gandhi died. In fact, a speedy cremation was the Hindu custom
and was what Gandhi had wished.

Once the cortège had moved off we drove back to Government
House – because it would take hours for it to arrive at the Raj Ghat
– and then set off there ourselves by a route which would avoid the
funeral procession. Nehru was walking with it – the family, all the
Cabinet, all his political associates, including all the '20 anna
congressmen', all barged in – no protocol was observed and there
was slight chaos.

When we arrived at Raj Ghat, we were a party of some twenty
people. There were also all the visiting Governors who had come to
Delhi for the Governor's conference. Then there was the Diplomatic
Corps. We were standing immediately in front of a low platform on
which logs were piled for what would become the
funeral pyre. Realising that once the funeral cortège arrived it would
all be such a huge crowd, my father insisted that the VIPs sit cross-
legged on the ground – he was afraid that they might have been
pushed into the flames once the funeral got underway and emotions

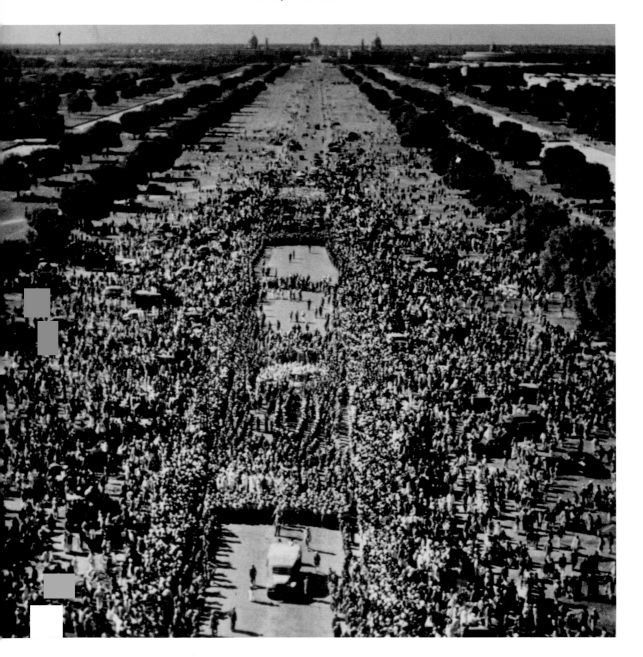

The funeral procession moving down Kingsway (note: Dome of Government House on sky line).

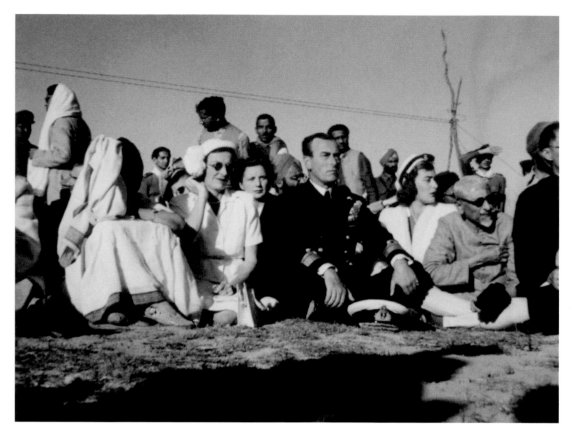

Our family seated in front of Gandhi's funeral pyre.

ran high. It was an extraordinary sight seeing the cortège in the distance and then arriving: the press of people was so huge that of course they had been able to break through the servicemen's lines. A vast crowd followed and became part of it, adding to the enormous crowd already assembling. Very soon there were about seven lakhs –700,000 people.

Gandhi's body was placed on logs which were built up higher, then sacred oils and ghee were sprinkled on it and Gandhi's son lit the pyre. It was a horrifying moment watching a beloved body being consumed by the flames, but strangely enough the horror soon wore off and one almost felt a rejoicing with everyone in the crowd trying

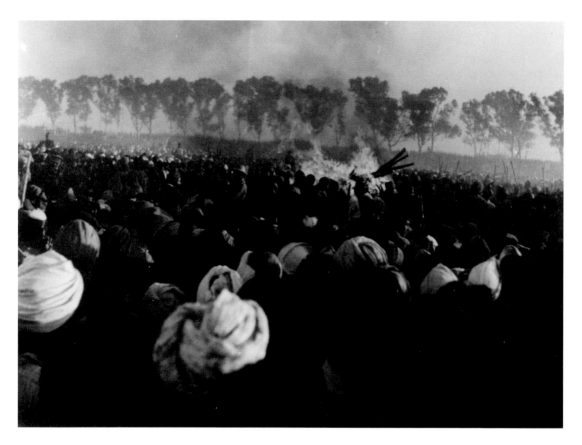

The pyre set alight to cries of 'Gandhi is immortal!'

to press forward and throw flowers. Then there was horror again
as some of the village women rushed forward hysterically to try to
commit *sutee*. But mercifully they were prevented. It really did
become a scene of wonder and rejoicing as the flames engulfed him
and the cry rose up, 'Gandhi is immortal!'

By this time the crowd had become so emotional that my father
stood up to assess the situation and decided that if he was going to
get all the VIPs back alive a strategic withdrawal would be in order –
so he told us to make a human chain and discreetly make our exit.
Recognising him in his naval uniform, the crowd very considerately
parted for us and we were able to get through to the cars.

The Prime Minister doing Yogi.
He used to do his early morning
telephone calls like this

Tours Part II:

February – May 1948

After the shock of Gandhiji's assassination the country was in mourning, but life at Governor-General's House was as busy as ever. The first Governors' Conference to take place after the transfer of power gathered at the House. There had been no time to cancel it after Gandhi's death so most attended the cremation with us. More friends came to stay and we took up our hectic tour schedule again, including an official trip to Rangoon to return the throne of Theebaw. At least in May we could go one last time to Simla and Mashobra and we could take Panditji, by now a dear friend, and at this time in desperate need of a break from the weight of the country's problems. The month ended with what seemed to be hundreds of farewell parties before our planned departure in June.

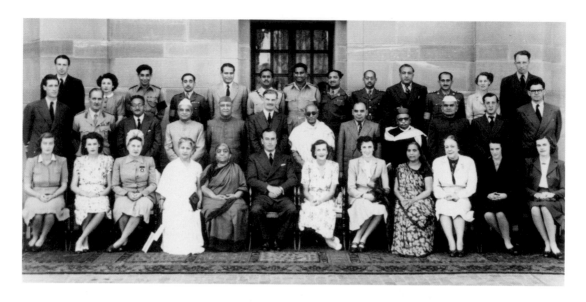

3rd February: Conference of Governors of the Indian Provinces after Independence with their wives, Senior Staff and House Party.

Sunday 1st February
Most of the Governors are here for the Governors' Conference tomorrow.

At the first of the Governors' Conferences, which now took place with all Indian Governors, we had a very formal lunch party. My mother was worried that one of the Governors appeared not to be eating at all, so she asked his ADC to find out why. Would he like different food, is he vegetarian, what can we give him? So she sent a message, 'Would His Excellency like an egg or is there something wrong?' Of course there were so many different dietary stipulations in meetings of this sort in India – you had ribbons on the backs of the chairs to denote someone who was vegetarian, or Hindu with no beef, Muslim with no pork. But maybe we'd made a mistake and he couldn't eat what we had prepared for him. The young officer went over to his Governor and there was a whispered conversation, the officer disappeared out of the dining room and came back with a small, carefully wrapped parcel which he handed to the

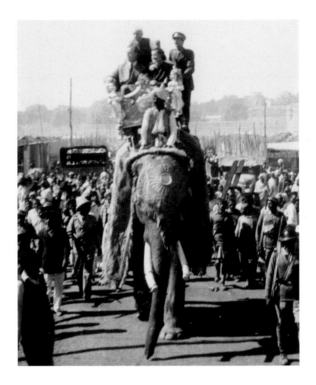

*9th February: My parents with Nehru in a howdah on
an elephant proceeding to the Mela – Allahabad.*

kitmagar to put on the silver salver with whispered instructions to
take it to the Governor. Unfortunately the kitmagar misunderstood
which of the many Governors it was for and presented it with great
ceremony to the Governor of Bombay, sitting on my mother's right
hand. The Governor of Bombay was Sir Maharaj Singh, an
extremely educated cosmopolitan Governor, and he was slightly
startled by the salver being presented to him. He unwrapped the
parcel to discover ... a pair of false teeth! The teeth were quickly
wrapped up again and taken round the table to their rightful owner,
who was a lovely man, the Governor of Orissa, Dr Khaju, a great
scholar who also used to write detective stories like Sherlock
Holmes. He was delighted to receive his teeth which he popped in,
and thereafter he ate with relish.

*9th February: Some of the million bathers at the Confluence
of the Ganges and the Jumna.*

Also at that first Indian Governors' lunch, my sister Patricia had
quite a tough time talking to her neighbour but she had struggled
on and ultimately he seemed very appreciative of what she was
telling him. She had been describing the ceremony of Princess
Elizabeth's recent wedding to Philip. She had described the enormous
enthusiasm of the crowds, the pageantry, and what a fantastic
day it had been. She was appalled to discover later that the Governor
in question had approached my mother at the end of lunch and
relayed that her charming daughter had been telling him all about
her wedding.

6th March: After investiture in Durbar Hall.

Monday 9th February
To the Mela with Nehru at Allahabad.

Thursday 12th February
Gandhi's ashes were scattered after a service of memorial at the Cathedral
Church of Redemption. Daddy read a lesson and we sang Gandhi's
favourite hymns including 'Abide with Me'.

Friday 13th February
We visited the famous Doon School at Dehradun. When we left, cars lined
up to shine their headlights on the runway to allow us to take off.

7th March: My father leaving Delhi University (wearing the gown of a Doctor of Science) with my mother and Nehru.

Friday 5th March
Patel suffered a heart attack, the general concensus is that it comes after the strain he has been under since Gandhiji's death. His doctors have insisted that he removes himself from all government matters. This will be difficult as he and Nehru are such key figures.

Monday 8th March
We set off on tour again, this time to Calcutta, Orissa, Rangoon, and Assam. Our schedule is incredibly tight and Mummy and Daddy will be very busy. The schedule has been printed up in four different coloured books. As a party (including staff) we number about 50.

Tuesday 9th March
After a very busy day we had a family dinner at the oldest golf club in the East, founded in 1829.

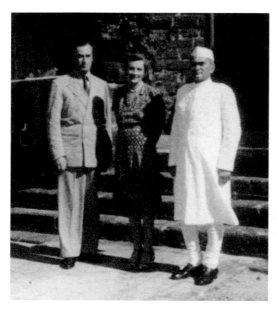

10th March: My parents with H E Dr Khaju, Governor of Orissa, at Government House, Cuttack (left). My parents having overshoes fixed before visiting the temple in Orissa (right).

Wednesday 10th March
To Orissa where we were met by the Governor Dr Khaju. While we were there the Naval ADC, Lieutenant Pran Parashar's over-enthusiasm got us into serious trouble. We were visiting a temple and the priest warned that we would not be allowed into the Holy of Holies. Pran was outraged on our behalf. Explaining that he was a Brahmin of a much higher caste than the priest, he swept us into the forbidden area. The next morning, as we were reading the newspapers, we saw the headline: 'Temple closed for purification after being polluted by Governor-General's Visit.'

Thursday 11th March
Rangoon. All Burma's important Governors present.

Saturday 13th March
Returned from Rangoon to Calcutta. Went to exhibition. Mummy did

13th March: Naga Tribesmen arrive to do war dance at Shillong.

a final recording for All India Radio to say goodbye to the people of West Bengal.

On 21st March Alan Campbell-Johnson wrote in praise of my mother's ceaseless activity in her leadership of the United Council. He recorded that, since the end of August 1947, she had made ten 'major tours up to the end of January, carrying out seventy inspections of individual refugee camps and fifty tours of hospitals. All this is on top of the Mountbattens' general tour schedule, in which they are still trying to complete a five-year Viceregal progress in nine months. During a further ten tours to states and provinces she has paid sixty-six visits to hospitals, social-welfare centres, colleges, training establishments etc. It is a prodigious effort of body and spirit, and has captured the imagination of India as only the propaganda of deeds can do.'

24th March: The family and staff on Lake Trivandrum.

Between 20th March and 5th April we visited Kapurthala, Travancore, Cochin and Udaipur.

Sunday 20th March
The Maharaja of Kapurthala is 76 and has been on the gadi since the age of 5. He has seen many Viceroys and Vicereines come and go. At the State Luncheon welcoming Mummy and Daddy he stood up and bade everyone 'drink to the health of Lord and Lady Willingdon.'

After Kapurthala we spent twenty-four hours in Udaipur and saw the beautiful lake with its unused palace and the city palace. The Maharanas of Udaipur were treated with great veneration

12th April: Leaving Bodh Gaya Temple, Bihar.

because they refused to visit Delhi when the Moghuls occupied it. Princes like Jaipur bowed very low before the Maharana. When we visited, the ruler was old and frail and a cripple. He was a tiny little man. My mother and I visited the Harem to pay our respects to the Maharani – a special dispensation on the part of His Highness. We were escorted by the Chief Minister. He whispered that he was her brother but had not been allowed to see her since her wedding (about forty years before!).

As our plane took off, our last glimpse was of the Maharana being lifted high into the air on his chair by his retainers to get him out of the dust of our slipstream.

*12th April: Going to visit the tree under which enlightenment
came to Gautama Buddha.*

At the end of March, the conductor, Malcolm Sargent arrived
to stay. He was on his way to Turkey but unfortunately my mother
was so busy working that she didn't have the time to see him when
he first arrived. On the 1st April we took him to see some Indian
music and dancing – he was fascinated by the fact that they all
played perfectly in time without a conductor. Unfortunately he got
dysentry and was unable to fly on to Turkey which was
fortunate for us because he could stay longer – we had a party
by the pool on the 16th April when Panditji demonstrated his
yoga posture standing on his head – a position which he practised

16th April: Jawaharlal Nehru at Government House pool.

every day – he even took phone-calls like this. After Malcolm left, my mother went to see Panditji and from this moment on, as her demanding work schedule began to ease slightly, their friendship blossomed. She invited him to come with us in May to Mashobra.

Friday 7th May
To Bundi to stay with Rao Raja of Bundi.

Saturday 15th May
We were able to go up the glorious Himalayas for a stay at Simla.

E. with Mizzen. Malcolm in pool.

Saturday 21st May
We gave a garden party for the East Punjab dignitaries. The band
played, and the dress, of course, was morning coats and top hats and our
best hats and white gloves and a crowd of beautiful saris and
shalwar kameez.

Monday 24th May
We visited Patiala. The 6'4" Maharaja is truly magnificent with beard
and pugaree. We watched a cricket match. If a boundary is hit the ball
disappears down the mountainside. Great loss of balls.

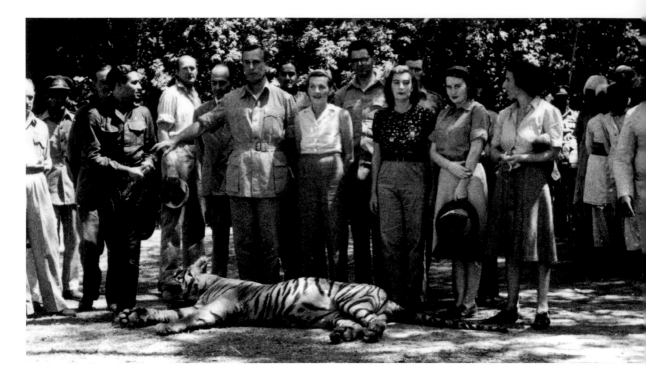

7th May: Shooting party in Bundi: my father touching the arm of our host,
Bahadur, Maharajah of Bundi.

Tuesday 25th May
We returned to Delhi.

Sunday 30th May
There are going to be three weeks of farewell parties.
Mummy visited the two great refugee camps of Kurukshetra and
Panipat which still shelter 300,000 people. One of the Indian ADCs
who accompanied her said that he had never seen anything like it.
The refugees gathered round her in their thousands, in tears at saying
'goodbye' to her. In many other camps, refugees collected their Pice and
Annas to buy a railway ticket for one of them to carry a small gift to
her as a token of gratitude.

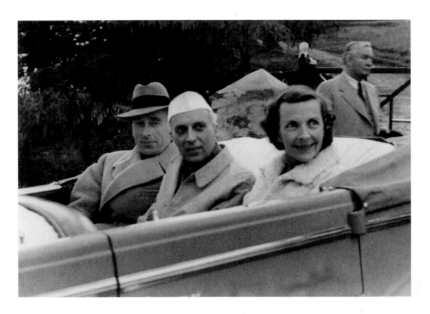

15th May: My parents and Nehru setting off on an expedition to Narkenda from Mashobra (behind car – Head Gardener, Reader).

Nehru, my parents and me looking at a bear on a drive in Simla.

Breakfast at 'The Retreat' at Mashobra with Nehru.

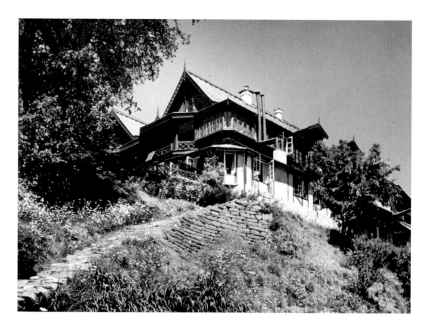

'The Retreat' in Mashobra near Simla
taken during our last stay, 13th-17th May.

A small section of the Garden Party on 21st

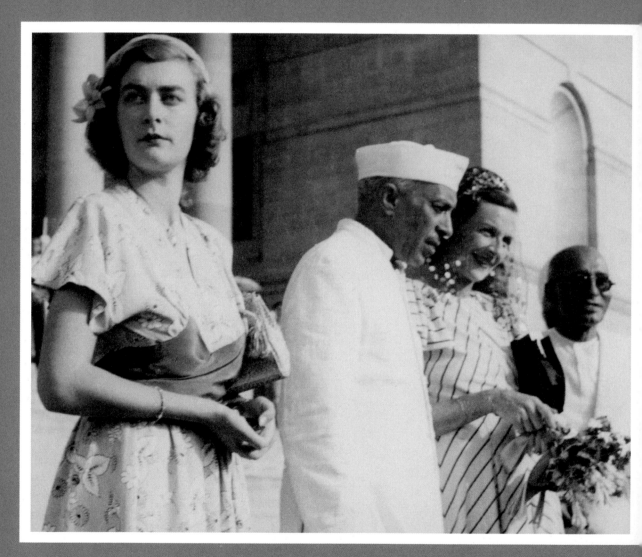

Waiting to leave Government House, with Panditji, my mother and Rajaji.

Departure:
June 1948

We had been on an incredible journey with India, which had changed the sub-continent, and had a lasting effect on my family. After all that had happened it was hard to believe we were leaving.

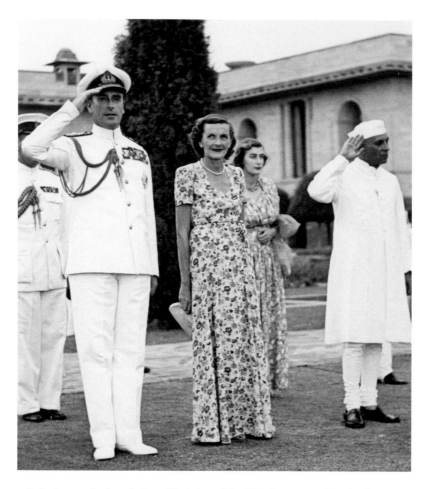

Saluting as the band plays 'God Save The King' on arrival at the farewell party for over 2000 staff.

Sunday 20th June
Our last day, we drove to Old Delhi through dense crowds along the Chandi Chowk. Apparently no Viceroy had driven down it since an assassination attempt on Lord Hardinge in 1911. We were cheered all the way to the Gandhi grounds [Raj Ghat]. A crowd of 250,000 had gathered there and the same number were still trying to get in.
A Farewell Address was given on behalf of the Delhi Municipality.

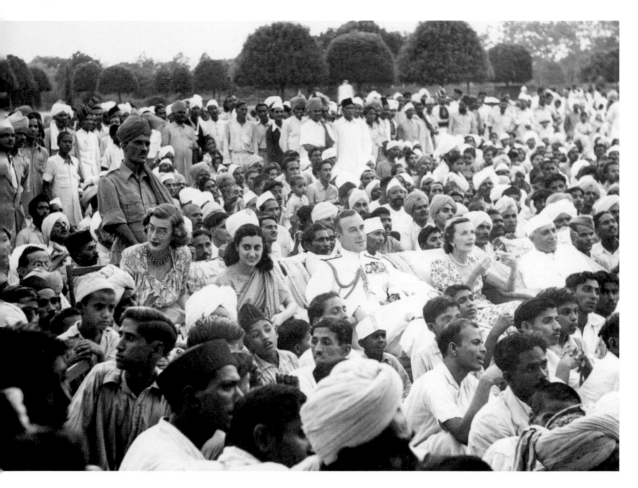

P, Indira Gandhi, my parents and Nehru at a performance in the Moghul Gardens at the farewell party for the entire staff.

The farewell party for all 2000 staff was enjoyed by all. So many people had come out to say goodbye to us. The entertainment included various performances, watched by my family and surrounded by friends and staff.

Photo inscribed by Rajagopalachari for my father's birthday at his reception at Government House. The caption reads 'Dear Magician, Thus was I inducted into trouble by you, Raja.'

Our last State Banquet was held this evening. It was hosted by the Cabinet in Government House. Panditji said of Daddy: 'You came here, Sir, with a high reputation, but many a reputation has foundered in India. You lived here through a period of great difficulty and crisis, and yet your reputation has not foundered. That is a remarkable feat.' He then spoke about Mummy as having 'the healer's touch. Wherever you have gone, you have brought solace, you have brought hope and encouragement. Is it surprising, therefore, that the people of India should love you and look up to you as one of themselves and should grieve that you are going?' He even mentioned me as 'coming straight from school, and possessing all the charm she does, did grown-up person's work in the troubled scene of India'. He referred to the public demonstration in Old Delhi this morning, saying 'I do not know how Lord and Lady Mountbatten felt on that occasion, but used as I am to these vast

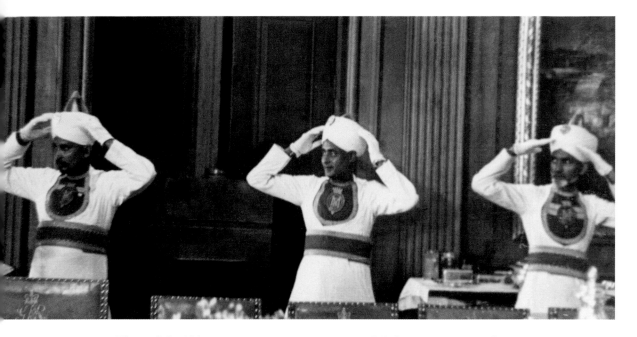

Three of the 100 servants receiving my parents with Salaams on entering the State Dining Room which was taken over for the evening by the Government to give the farewell banquet.

demonstrations here, I was much affected, and I wondered how it was that an Englishman and Englishwoman could become so popular in India during this brief period of time... A period certainly of achievement and success in some measure, but also a period of sorrow and disaster... Obviously this was not connected so much with what had happened, but rather with the good faith, the friendship of all English men and women, and indeed of all the people in the United Kingdom to the people of India and the love of India that these two possessed... You may have many gifts and presents but there is nothing more real and precious than the love and affection of the people. You have seen yourself, Sir and Madam, how that love and affection work.'

Mummy and Daddy replied very movingly and then they were presented with a silver tray inscribed with the signatures of all the Governors of the Provinces and the Members of the Cabinet.

General view of the farewell banquet showing the usual 104 at the main table. Note the Union Jack and Indian Flag concealing the Gold Plate.

My father pulls back the flags to make a surprise presentation of the King Emperor's Gold Plate on behalf of the King.

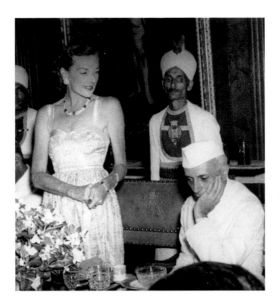

E. thanks Cabinet Ministers and Governors of Provinces for the silver tray inscribed with their signatures presented to D. and E.
Note her Khidmatgar Lachhi Ram behind her.
After dinner 7000 guests came to say goodbye

Finally, Daddy presented the magnificent gold plate which the
Worshipful Company of Goldsmiths and Silversmiths had presented to
the King Emperor George V for use in his Viceroy's State Dining Room
in New Delhi. Daddy said that he did this at the King's express wish as
a symbol of friendship. The evening ended with a reception for seven
thousand guests.

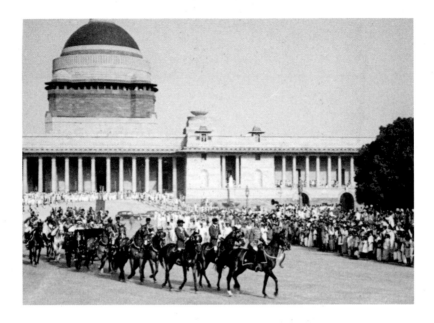

After near side leader had jibbed and refused to move.
Both leaders had to be taken out to continue with 4 horses
The crowd yelled " Even the horses won't let you go!"

Farewell Ceremony

When the time came to leave my mother and I were very
emotional and sad. It was horrible to say goodbye to people like
Rajaji, who was succeeding my father as Governor-General.
Because Indians are an emotional people it's very catching and it
is incredibly hard to keep a stiff upper lip when somebody hugs
you in floods of tears. But the moment I'll never forget is when
we got into the carriage and were about to drive away with a
mounted bodyguard.

Left: My mother and I watching my father inspect the Guard of Honour.

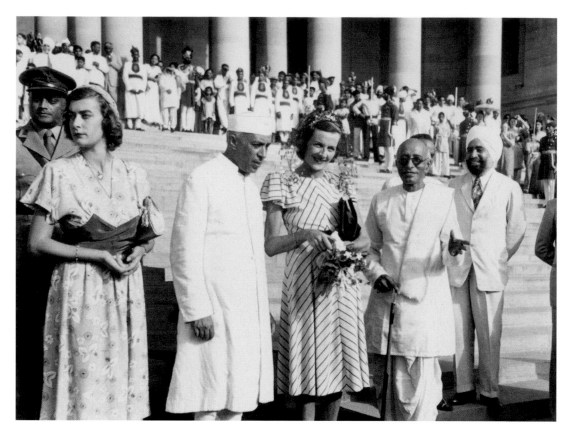

Gathered outside Government House waiting to finally leave.

Monday 21st June
We left Government House with the Bodyguard lining the steps and
escorting the carriage. But as we were about to move off one of the horses
jibbed. Someone called out: 'Even the horses won't let you go' and the cry
was taken up by the crowd. By the time we had the official farewells at
Palam Airport, Rajaji was weeping and Mummy and I were finding it
very hard to hold back our tears.

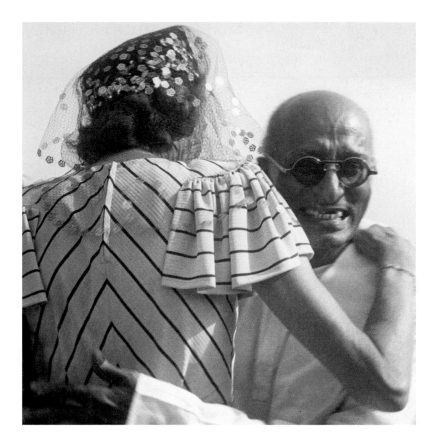

An emotional farewell from the new Governor-General 'Rajaji'
(Rajagopalachari).

'I wondered how it was that an Englishman
and an Englishwoman could become so popular
in India during this brief period of time.'
Nehru at the Mountbattens' last
State Banquet

*Front row: Philip, my father, Shanmukham Chetty, Attlee, my mother,
Krishna Menon, Indian High Commissioner.*

*We arrived back at Northolt on a warm summer's evening and the Prime
Minister, Philip, the Indian Minister of Finance, Krishna Menon, the
BBC and various press photographers and agencies were there to meet us.*

Despite the tributes and show of affection on our departure,
not everyone was keen to welcome us home. Winston Churchill
and many in the Conservative Party and beyond blamed my
father for the loss of life that had taken place. Churchill was never
to forgive him for 'giving away the Empire' and cut him dead at
every Buckingham Palace Garden Party. They thought every-
thing had being done too quickly, but my father knew that only
history could be the judge. My parents had the love of the Indian

*My father, Shanmukham Chetty, Indian Minister of Finance, UK Prime
Minister Attlee and my mother at Northolt RAF station.*

people and the thanks of Congress who knew that there was no
way of containing the rioting without moving quickly to transfer
power to India itself.

*Overleaf: Royal Indian Naval Guard of Honour from HMS Delhi,
which was being commissioned in the UK when we returned from India.*

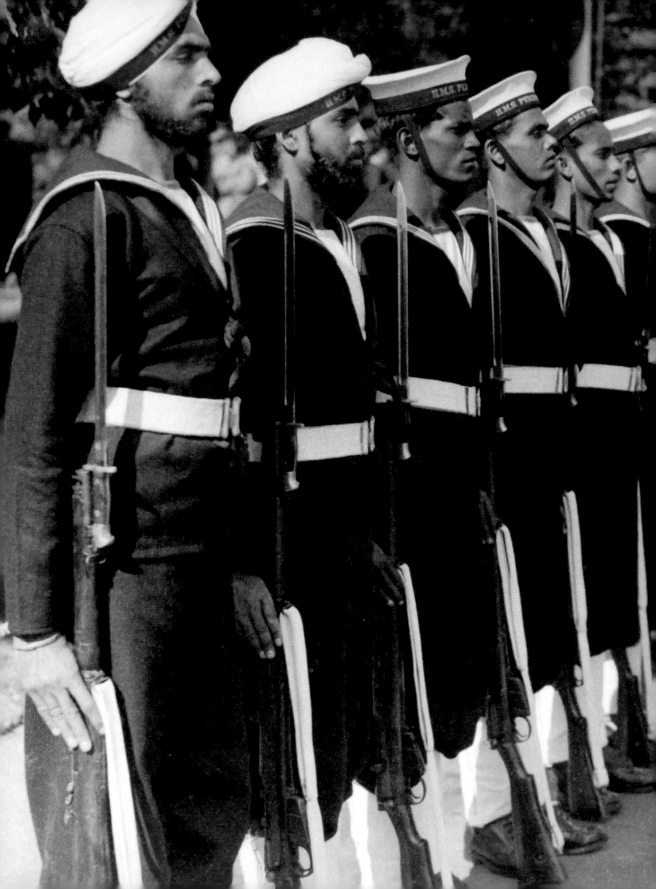

Epilogue

When I left India to return to England I was 18 years old.
I felt I was returning to a country where I knew hardly anybody.
All my coming out into the world, and meeting people my own
age, and discussing all the things that mattered so much when
you are that age – politics and religion and boyfriends and every-
thing, had happened with Indian girls. I felt far more Indian than
English. Maybe this made it possible for Indians to feel the same
way about us. Therefore, one felt accepted. One was in a country
and one was doing something; one felt part of it. But I think it
would have been very difficult not to. I do not think you really
could have lived through that time and remained an onlooker.

Key Figures

ABELL, George (later Sir George): Private Secretary to the Viceroy

AMRIT KAUR, Rajkumari: Gandhi's Secretary, Minister for Health in the Government of the Dominion of India

AUCHINLECK, Field-Marshal Sir Claude: Commander-in-Chief in India until 15th August; Supreme Commander administering partition of Indian army until 30th November 1947

BALDEV SINGH, Sardar: Sikh leader; Member for Defence in the Interim Government, Minister for Defence in the Government of the Dominion of India

BHOPAL, The Nawab of: Ruler of Bhopal State; Chancellor of the Chamber of Princes until May 1947

BIKANER, The Maharaja of: Ruler of Bikaner State

BRABOURNE, Lord and Lady, Patricia and John: Elder daughter and son-in-law of Earl and Countess Mountbatten of Burma

BROCKMAN, Ronnie, Captain R.N.: Personal Secretary to the Viceroy, Private Secretary to the Governor-General of India from 15th August 1947

CAMPBELL-JOHNSON, Alan: Press Attaché to the last Viceroy and to the first Governor-General of the Dominion of India

COLVILLE, Sir John: Governor of Bombay until August 1947, Viceroy during Mountbatten's absence in London

CURRIE, Douglas, Colonel: Military Secretary to the Viceroy and to the Governor-General of India

GANDHI, Mahatma, Gandhiji: 'Bapu' (Father of the Indian Nation)

GILLIAT, Martin, Major: Deputy Military Secretary to the Viceroy and to the Governor General of India

HOWES, Peter Lieutenant Commander, R.N: Senior ADC to the Viceroy and to the Governor General of India

ISMAY, 'Pug', Lord Hastings: Chief of the Viceroy's Staff and of the Governor-General of India's staff until December 1947

JAIPUR, Maharaja of: 'Jai', Ruler of Jaipur state

Key Figures

JAIPUR, Maharani of: 'Ayesha'

JENKINS, Sir Evan: Governor of the Punjab until 15th August 1947

JINNAH, Mohammed Ali (Quaid-e-Azam): President of the All India Muslim League, first Governor-General of the Dominion of Pakistan

JINNAH, Fatima: Jinnah's sister

KATJU, Dr: Governor of Orissa after August 1947

KAPURTHALA, The Maharaja of: Ruler of Kapurthala state

KASHMIR, The Maharaja of: Ruler of Jammu and Kashmir state

KRIPALANI, Acharya: President of Congress

LIAQUAT, Ali Khan: General Secretary of the All India Muslim League; Member for Finance in the Interim Government; Prime Minster of the Government of the Dominion of Pakistan

MAHARAJ SINGH, Sir: Governor of Bombay after August 1947

MENON, V. Krishna: Prominent in India League, Member for Paddington on London County Council, Nehru's Representative in Europe, High Commissioner to the United Kingdon from August 1947

MENON, V.P.: Reforms Commissioner to the Viceroy; and from July 1947 Secretary of the States Department, Government of the Dominion of India

MIEVILLE, Sir Eric: Principal Secretary to the Viceroy

MONCKTON, Sir Walter: Constitutional Adviser to the Nizar of Hyderabad

NEHRU, Pandit Jawaharlal, 'Panditji': Member for External Affairs and Commonwealth Relations in the Interim Government; Vice-President of the Interim Government; Prime Minister of the Dominion of India

NYE, Sir Archibald: Governor of Madras

PANDIT, Mrs Vijaylakshmi, 'Nan': Nehru's sister, Ambassador to Russia and to the United Nations

PATEL, Sardar Vallabhbhai: Member for Home Affairs and for Information and Broadcasting, and from July 1947 for States in the Interim Government; Deputy Prime Minister for the Dominion of India
PATIALA, Maharaja of: Ruler of Patiala State, and from May to August 1947 last Chancellor of the Chamber of Princes

PRASAD, Dr. Rajendra: Member for Food & Agriculture in the Interim Government and President of the Constituent Assembly

RAJAGOPALACHARI, Chakravarti 'Rajaji': Member of Industries and Supplies in the Interim Government; Governor of Bengal after 15th August 1947 and first Indian Governor-General of the Dominion of India 21st June, 1948

REES, Major-General T.W., 'Pete': Commander of the Punjab Boundary Force July to September, 1947; Head of the Governor-General's (India) Military Emergency staff September to December 1947

UDAIPUR, Maharana: Ruler of the state of Udaipur

WARD, Elizabeth: Lady Mountbatten's Private Secretary

WATSON, Muriel: Lady Mountbatten's Personal Assistant

WAVELL, Earl: Viceroy of India whom Lord Mountbatten succeeded

Glossary

Angrezi: English/British
Bapu: literally, 'Father'
Bearer: a valet
Chaprassi: an office messenger
Dhoti: a long, unstitched cloth wound about the lower part of the body
Durbar: literally, Kings court
Gadi: a throne
Howdah: a seat placed on the back of an elephant
Jai hind: a salutation, literally, 'Victory to India'
Jirga: decision making assembly
Ki jai: a salution, literally, 'Praise'
Kirpan: ceremonial sword worn by Sikh men
Kitmagar: a footman
Mahatma: 'Great Soul'
Mela: festival
Nawab: Muslim ruler or nobleman
Pandit: a learned man, often a Kashmiri Brahmin
Pathan: tribe of North West Frontier in India
Pugaree: a type of turban
Raj Ghat: Royal burial ground
Sutee: the Hindu practice of a widow throwing herself on the funeral pyre
Syce: a groom
Taktaposh: Royal bedstead
Zindabad: 'Long live'

Index

Picture credits

All of the images in this book and the cover image were sourced from the Broadlands Archive, with the exception of the following:
Corbis/Bettmann 25, 154, 157, 195; **Corbis/Condé Nast Archive** 178; **Corbis/Hulton-Deutsch Collection** 73, 171; **David Duncan Douglas/Harry Ransom Humanities Research Center. The University of Texas at Austin** 117; **Getty Images/Margaret Bourke-White** 52, 165; **Getty Images/James Burke** 131; **David Hicks** 59; **Dana Hyde** 51; **Photo Division/Press Information Bureau, Ministry of Information & Broadcasting** 215 bottom; **RIBA Library Photographs Collection** 53; **SuperStock/Age Fotostock** 111.
We apologise in advance for any unintentional omission or neglect and will be pleased to insert the appropriate acknowledgement for any companies or individuals in any subsequent edition of this work.

Bibliography

Alan Campbell-Johnson, *Mission with Mountbatten*, Atheneum 1951
Larry Collins and Dominique Lapierre, *Freedom at Midnight*, Harper Collins 1975
Philip Zeigler, *Mountbatten: the Official Biography*, Phoenix Press 1985
Interview with Lady Pamela Hicks recorded by B R Nanda for the Nehru Memorial Museum and Library, 14th October 1968

Acknowledgements

Our heartfelt thanks go to Kate Oldfield, without whom this book would not exist, and who made the writing of it such a pleasure for mother and daughter.

We are grateful to Dr. Chris Woolgar, Head of Special Collections of the Hartley Library, University of Southampton, and particularly to his senior archivist, Karen Robson. And to Lord Brabourne, our nephew and cousin who is the Chairman of the Trustees of the Mountbatten archives.

We also wish to thank Lotte Oldfield for her eye and enthusiasm.

And thanks to all the invisible hands who make books possible, especially Kate Burkhalter, for holding it all together, Anna Cheifetz, Michael Wicks and in particular Polly Powell.

Endpaper: Miniature Star of India brooch given as an 18th birthday present to Pamela Mountbatten by her father